HAUNTED
CHATTANOOGA

HAUNTED
CHATTANOOGA

JESSICA PENOT + AMY PETULLA

Published by Haunted America
A Division of The History Press
Charleston, SC 29403
www.historypress.net

First published 2011

Manufactured in the United States

ISBN 978.1.60949.255.7

Penot, Jessica.
Haunted Chattanooga / Jessica Penot and Amy Petulla.
p. cm.
ISBN 978-1-60949-255-7
1. Haunted places--Tennessee--Chattanooga. 2. Ghosts--Tennessee--Chattanooga. I.
Petulla, Amy. II. Title.
BF1472.U6P46 2011
133.109768'82--dc23
2011022619

CONTENTS

ACKNOWLEDGEMENTS

There are so many people who helped make this book possible, and we would like to thank everyone who helped it grow from the seed of an idea to a full-fledged manuscript. If it were not for all of these folks, this volume would never have been born.

First and foremost, we would like to thank everyone who shared their ghost stories with us, both those who did this in confidence and those who allowed us to use their names. At some time in our lives, everyone has heard that creak in the closet, strained to listen for the footstep down the hall, seen images dancing in the dark, sensed a presence that could not quite be seen or felt the gentle touch of a sudden cool breeze and experienced an icy caress of fear. Most of us claim to have put those things aside upon reaching adulthood, but this book owes a great debt to those who instead embraced the shivery pleasure of those moments and shared them with others. Ghost stories and legends would not exist were it not for those who are unafraid to acknowledge that they have experienced something not currently recognized by science. We would particularly like to thank the teams from PROSE, TPIT and Southern Ghosts, as well as the staffs of South Pittsburgh Hospital and Raccoon Mountain Caverns.

We would also like to thank our families, who have patiently waited as the vacuum was ignored in favor of the computer and who have accompanied us on countless research and ghost hunting trips. We promise to return to the land of the living now.

Likewise, we thank all of those who haunt the nation's libraries, whether as helpful staff, eager patrons or generous donors, for if it were not for these folks, the imagination that has made this country great would be a mere ghost of the soaring, vibrant, ever-changing entity that fuels brilliant minds. While libraries need to adapt to the times and modern technology, those who are proposing the closure of local libraries in the name of economic cutbacks are woefully shortsighted, and we hope our readers will let their voices be heard on this issue.

Finally, we would like to thank our commissioning editor, Will McKay, and our project editor, Ryan Finn, without whose encouragement and helpful feedback this book would never have been written. Following are a few short individual acknowledgements.

Amy: I would like to thank all of our guests at Chattanooga Ghost Tours, Inc, who have shared their stories and photos, as well as validated, with their shivers and shrieks and wonderful feedback, my dream of opening a ghost tour here. Also, thank you to the staff of the Chattanooga Hamilton County Bicentennial Library downtown, as well as Dr. Daryl Black of the Chattanooga History Center, for their endless patience and help as I researched both the tour and book. I would especially like to thank my coauthor, Jessica, who eased my fears and whose invaluable experience and advice made this process so smooth. Thank you, too, for writing the stories about places also included on the tour, to provide a different perspective. I could not have asked for a better partner in this matter! Finally, thank you to Melody, Chris and Angela for going with me on many, many ghost tours all over and enjoying them as much as I did, and to Dan, for your patience during it all.

Jessica: Thank you to my husband, Alex Penot, who has traveled with me to explore many haunted sites and supported me through this entire process. Also, thank you to my coauthor, Amy, for sharing her firsthand knowledge of Chattanooga's ghosts.

INTRODUCTION

Chattanooga is blessed with an abundance of natural beauty and a wealth of resources, both native and man-made. From the Appalachian Mountains to the Tennessee River, from the many caverns and lakes to downtown's profusion of attractions, the city has a wealth of possibilities. But when it comes to ghosts, Chattanooga truly has an embarrassment of riches. The difficulty is not in coming up with stories to include, but rather in deciding which ones to leave out. So many occult myths weave in and out of the River City's dazzling historical tapestry that they could not all be set out in one book. We have therefore included a mixture of the best-known and most interesting tales, though some favorites—such as the Chattanooga Theatre Centre and the Headless Dog of Douglas Street—will have to wait for another day.

Many factors contribute to Chattanooga's supernatural cornucopia. The Civil War played a large factor in the city's history. Few areas of the city do not have some claim to a relationship with a battle or individual of the War Between the States. In fact, the Battle of Chickamauga was the second-bloodiest battle of the entire war. As one would expect, many soldiers continue to haunt the area's battlegrounds. Nor is the Civil War the only conflict that has a special connection to this section of the country. The last battle of the American Revolution, in fact, was fought on very haunted Lookout Mountain—about a year after that war officially ended. Battles are far from the only source of the city's specters, however. The city was occupied by Native Americans from prehistoric times until various inequitable treaties,

from the Treaty of Sycamore Shoals opposed by Dragging Canoe to the Treaty of New Echota, until the eventual Trail of Tears removal of the Cherokee, during which four thousand to six thousand men, women and children died. In addition, as with any city, Chattanooga has had its share of murder, mayhem and misery, all of which can thin the curtain between this world and the next.

Geologic factors also contribute to the hauntings. Many paranormal investigators say that certain minerals are associated with supernatural activity. In particular, limestone (which liberally riddles Chattanooga) is thought to be capable of generating a "residual haunting," because it can store information through its ability to conduct and enhance electromagnetic energy—in particular, intense emotional energy generated by traumatic events. Thus, those types of hauntings are in the nature of a recording or memory, replaying itself exactly with no apparent awareness of the living, rather than an intelligent entity capable of interacting. Certainly, some of Chattanooga's spirits fall into this category, such as the Memorial Cemetery Arch's Black Aggie or the distraught mother at the Choo Choo. However, the actions attributed to many of the phantoms here show a clear and sometimes alarming intelligence.

Chattanooga's many ghosts have given rise to a profusion of paranormal investigators. Those include Tennessee Paranormal Investigative Team; Paranormal Researchers Of the South East; South East Paranormal Society; Chattanooga Paranormal; Ghosts & History of Southeast Tennessee; East Paranormal Investigators of Chattanooga; Tennessee Valley Paranormal; Cleveland Paranormal Research Society; Ghost Hunters of Soddy, Tennessee; and Chattanooga Paranormal Investigation Society. Most of these do their investigations at no charge, should any of our readers want their homes or buildings examined. We owe many thanks to all of the folks in the first two groups, along with many of the other people at the various locations mentioned herein, both named and anonymous, who shared their stories with us.

The stories we have chosen to share present you with a microcosm of Chattanooga's history. The development of the railways and the taming of the river, the changing face of the city in addition to its timeless natural landmarks and the cultural and educational progress of the people, as well as the Civil War and the Native American history—all factor into the paranormal legends that permeate the region in a blend that both educates and entertains. So turn on all of the lights and check under the bed before curling up with the covers pulled tight—a night filled with the spirits of southeast Tennessee lies ahead.

Haunted Hales Bar

AMY PETULLA

You have bought a dark and bloody land, and it is cursed.
—Dragging Canoe

Those are the words attributed to aggressive and outspoken Cherokee chief Dragging Canoe about Tennessee and Kentucky land given up by the Cherokee to white settlers in a treaty signed in March 1775. Some say that the exact words were: "You have bought a fair land, but there is a cloud hanging over it; you will find its settlement dark and bloody," but in any event, it has been accepted by all as a curse put on the land by the famed warrior in disgust as he walked out of the meeting, having adamantly opposed the transfer of any portion of the land.

Before this time, Chattanooga was continuously occupied by Native American peoples, beginning in the Upper Paleolithic Period (14,000–8,000 BC). Archaic, Woodland and Mississippian Indian sites have all been unearthed in and around Chattanooga. Cherokee Indians claimed the area in the late 1600s, after defeating the Shawnees occupying the region. In 1776, after the signing of the treaty, Dragging Canoe formed the Chickamauga Cherokee, urging likeminded tribe members to join him. They established—in an area near Chattanooga's present-day Brainerd Village shopping center—Chickamauga Town, which was destroyed twice by his enemies. After the second time, he moved his followers to a less accessible area and directed attacks from Running Water, Tennessee, near present-day Hales Bar.

Under Dragging Canoe's leadership, they vigorously endeavored to stop white settlement by attacking settlers all along the frontier. A fierce warrior, sometimes called "Dragon" by his enemies and suspected by some of possessing supernatural powers, he and his men captured and killed thousands of white men, women and children. Dragging Canoe died in March 1792 at Running Water. The accounts of his death vary. Some say that he died from exhaustion or a heart attack, complicated by a small wound that became infected, after a night of celebrating and dancing after securing either a battle victory or an alliance with other tribes; some report it as a scalp dance after the killing of the Collingsworth family, with his brother, Turtle At Home, grinding a scalp in his teeth as he danced; and some say that he died in battle with John Sevier, who later became Tennessee's first governor. The reports of his burial likewise vary. While some say that he was buried in a sitting position, in typical Cherokee fashion, others say that his body was stolen and cut in half, with the pieces buried miles apart, to prevent him from rising from the dead.

Perhaps those concerned about Dragging Canoe rising from the dead had a point. While at least one witness claims to have seen a cursing Indian ghost at University of Tennessee–Chattanooga (UTC), many folks insist that Hales Bar, just a couple of miles down the road from his death and burial site, is haunted and that, furthermore, the curse of Dragging Canoe is the reason it has been sinking for years. Many people, including the folks with Paranormal Researchers Of the South East (PROSE) who run the tours at Hales Bar, have had plenty of supernatural experiences there.

Up until the building of the Hales Bar dam, travel by river to Chattanooga was a perilous endeavor. The intrepid traveler who dared to attempt the journey had to navigate hazardous waters from Muscle Shoals, Alabama, to Chattanooga. The dangers while roaring through the Tennessee River Gorge, a twenty-six-mile stretch of canyon, included a number of shoals and shallow rapids, as well as a series of whirlpools, including "the Boiling Pot," "the Suck" and "the Skillet." In fact, the stretch between Shellmound and Chattanooga was considered to be the most formidable section of the entire Tennessee River. Because navigation by land was likewise hazardous, occupation by white settlers was sparse until about 1817, when John Brown, known as "the most skilled river pilot in the area," established his ferry across the river, along with a tavern to put up traders passing through. Still, while the ferry made navigation easier for traders once they got to the area, arriving in Chattanooga with goods intact continued to be difficult and impeded

growth and trade until two events occurred: the arrival of the railroad and the taming of the Tennessee River.

In 1900, Josephus Conn Guild first came up with a plan to both increase the use of water resources and curb the river's pitfalls. He wanted to build a dam to raise the water level and alleviate navigation dangers, as well as a powerhouse to harness the immense potential of hydroelectric energy afforded by the river. Studies were undertaken, money assimilated and federal legislation passed over the next five years, and construction on the first multipurpose hydroelectric dam in the country began in 1905 at Hales Bar. Five hundred men worked around the clock, six days a week, and the town of Guild, Tennessee, sprang forth to meet their needs. Stores, a schoolhouse and even an electrified train car were established to serve the community.

The Hales Bar dam, lock and powerhouse were completed in November 1913. However, a 1905 description of the dam's concrete gravity section as "keyed into solid rock" proved a fateful error. In fact, the foundation rock was limestone, with extensive fissuring and honeycombing that continued to erode over the years of constant water flow. A group of men known as "the Rag Gang" was hired to patch holes with rags and old carpet, but that barely put a dent in the implacable onslaught from the river. The Tennessee Electric Power Company acquired the dam and power plant in 1922, but all efforts to stem the water seeping under the dam were unsuccessful, and the caisson (the giant concrete box resting on the foundation) continued sinking. In 1939, TVA acquired the structure, believing that it could succeed where others had failed. After spending countless hours and millions of dollars in repair attempts, the curse of Dragging Canoe prevailed in 1963 when TVA decided to throw in the towel and replace Hales Bar with Nickajack Dam, since as much as 1,500 to 2000 cubic feet of water per second continued to escape the dam. In 1968, the Hales Bar lock and dam were demolished, with only the powerhouse remaining. Even the powerhouse continues to sink, however; the bottom three floors are submerged underwater.

The PROSE folks have had many supernatural experiences and have captured many electronic voice phenomena (EVPs) at the power plant. They believe that there are several different entities haunting Hales Bar. One is a woman, believed to have been murdered and raped in the powerhouse building itself. Michelle, a PROSE team member, heard the name "Rachel" spoken softly in her ear, but when she turned to see the speaker, no one was nearby. They believe that the ghost was identifying herself. Feelings of dread, fear and melancholy often creep over visitors in a particular portion of the upstairs of the powerhouse, particularly near one window. The terror of this

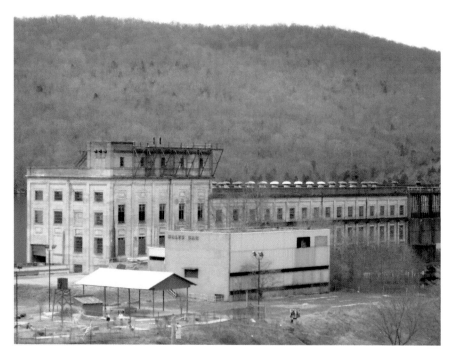

The Hales Bar powerhouse.

woman's last moments on earth seem to cling to the very walls themselves, as guest after guest is overwhelmed with the impression of a woman, struggling for her life as she is pushed ever closer and finally out of the window—falling, screaming, to a horrible death below. PROSE members have gotten EVPs there saying, "Don't leave," and, "I told you a secret." A man has also been seen looking out of an upstairs window when no one was in the facility. Is he looking for Rachel's body? If so, is it in despair over her loss or to ensure that the murder attempt was successful?

Other portions of the powerhouse have entities as well. More than one person says they have been grabbed to the point that they couldn't breathe. Dragging Canoe certainly had no aversion to such violence. Many appearances seem to be males, stalking individual PROSE members or the tour groups they are leading. At one point, a man in old-fashioned 1940s garb was walking right behind the tour group so clearly that he seemed to be real, though no one was wearing any costume, and the gentleman vanished. As I listened to the radio not long after my visit to the plant, a host began talking about an encounter he had at Hales Bar about a week

after I was there. He mentioned that he had caught a mist on film and had seen an odd man who disappeared when he looked briefly away. Other than curiosity about the man's strange appearance, he thought nothing of it until he heard later that the television show *Ghost Adventures* was there investigating the same day, which caused him to wonder if that explained the sudden disappearance. As he wondered aloud what the ghosts of Hales Bar were supposed to look like, he described the man he saw—wearing, in his words, old-fashioned 1930s clothing! When I called in to tell him about PROSE's description of the man in old-fashioned clothes that they thought was real until he disappeared, he initially was dubious; he was very much a skeptic when it came to ghosts. However, when he realized that I had not made up the description previously reported, his skepticism was shaken enough for him to follow up. He later posted a photo that a ghost hunter had sent him from that location that, he said, matched the phantom he had seen exactly.

On other occasions, the stalking spirit has appeared as a black shadow figure following people on the stairs near the entrance of the powerhouse. On the last investigation the group did before my visit, PROSE member Joseph's knees locked on the stairs, freezing him for a few seconds, and a team member at the foot of the stairs watched in horror as the shadow descended the stairs after him. On another occasion, the same shadow was seen going up the stairs after a group. From the main portion of the powerhouse, an upstairs level with several old lockers and a door can be seen, and one night the door became illuminated even though there was no one there. More than once, a shadow has been seen walking back and forth in front of the lockers. The *Ghost Adventures* crew actually secured thermal imaging of the pacer during the visit.

Located in the main part of the powerhouse is a short length of railroad tracks, going nowhere. Back in its heyday, however, Hales Bar had its own train for getting around. That vehicle is long gone, as are most of the tracks. Yet the train is still heard in the powerhouse and has even been caught on tape. Near the tracks is a staircase, and though you can only walk down half a flight of stairs before they become submerged underwater, that did not deter the shadow man from descending. On my visit, I walked the few steps above the flood line on this and another nearby staircase. It is an eerie, almost surreal feeling to look down from the top of the flight and see nothing but water everywhere, the floor invisible in the muddy depths.

The water around the powerhouse has its own mysterious rumors. Not far outside the building, just as at Suck Creek, is a "suck," a small whirlpool.

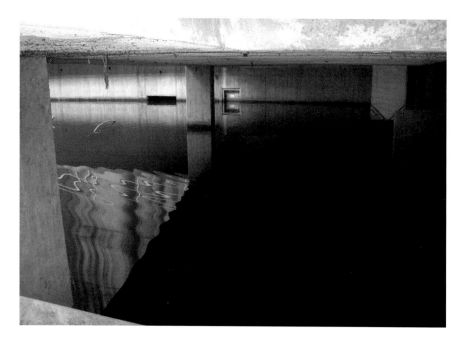

All but the top floor of Hales Bar is flooded as a result of sinking, which many attribute to the curse of Dragging Canoe.

According to PROSE member Victoria, Cherokee legend has it that the faces of those lost there over the years can be seen swirling in the pool. When the water current is flowing strongly, you can see an eddy spinning gently in the waters inside the building, as well, as the whirlpool is echoed there in smaller proportion.

Some people believe that one of the EVPs secured near Hales Bar is in the Cherokee or Choctaw language, although those unfamiliar with those tongues say it sounds like German. However, Cherokee contains some of the guttural sounds you hear in German, which could account for the confusion.

Dragging Canoe, the stalker and the murdered woman are far from the only ghosts at Hales Bar. An entire community developed around the building of the plant, including a small school for the children of the families who lived and worked there. Some of the children would cross from the other side of the river, through a narrow tunnel under the dam, to get to school. According to those who used it, even the tunnel leaked, causing those passing through to be sprayed with water. That tunnel was destroyed with the dam. Another tunnel continues to exist in the control building, and it is easy to see that children would have found it an entertaining place for hide-

and-seek and other games. It is believed that at least one little girl continues to play in the tunnels.

On one occasion, two of the team members recorded their daughter asking questions, as if to another child, and they played the tape in the part of the tunnel where the child had been reported. Team members asked her to turn a flashlight with its top loosened on or off for responses. After several minutes of no results, they finally said, "We'll have to leave here if you don't communicate." At that point the light came on, very brightly. At another point, they asked if the child thought that one of the tour members sitting nearby looked like her father. The answering bright flash of light was enough to cause the man to jump out of his seat and flee down the hall. At other times, PROSE members have left gifts for the child on a table of sorts, including a Slinky, a pink stuffed bunny, a teddy bear and candy. The toys were all missing on later visits, though the candy was left behind.

When I visited, as we stood at the table, an app on one group member's phone said, "Play." My son, who was with me at the time, refused to ask the child any questions, although he did say inexplicably, "Her mother and father are coming." While no one at PROSE mentioned the presence of the girl's parents, "JoeBob" with Tennessee Paranormal Investigative Team, which was actually the first paranormal group to explore Hales Bar, told me later that TPIT had encountered a ghostly family in that tunnel—mother, father and child! In addition, they had gotten responses to questions using the flashlight test and also by requesting the spirit to increase or decrease EMFs for yes or no. JoeBob, who debunks 99.9 percent of the photos I send to him and is not known for flights of fancy, also told me that something had clearly whispered, "Hey," in his ear at Hales Bar. After their investigation, he believed that there were ten to fifteen entities haunting Hales Bar—and not all of them nice.

Whistling and moans have been heard in the tunnel, and someone has been seen peeking around corners there when no one else was present. One girl was scratched by an unseen presence in this area. In other parts of the tunnel, it is rumored that bodies are buried in the wall. The company had a duty to take care of the men who worked there and their families, including disposal of the bodies of any who died there. Mixing them in with the concrete was an efficient solution. The walls may also have claimed workers for their own via industrial accidents in those days before OSHA. There is also a small cemetery on the grounds around the plant. As we stood next to the only grave for which they had reported prior paranormal activity, that of a man named "Barney," my phone began dialing numbers on its own.

It stopped as we left the grave. Maybe Barney was trying to figure out the newfangled technology.

Upstairs, footsteps and a woman's scream have also been heard in another area, though a hunt for the origin of the sound revealed no living person in the building. As we left by the red exit door, I got one final report. Rick is the skeptic of the group, the one who says he never experiences anything. Nevertheless, Rick described on a previous occasion hearing a voice distinctly say, "I'm here," as he stood alone next to the door. Whether this was an invitation to come back or a gentle reminder not to return (as the building is already occupied) remains to be seen.

On April 24, 2010, on the eighth annual Day of Prayer for the Western Band of the Cherokee Nation, a resolution was presented to and accepted by the Cherokee leaders at Tahlequah, Oklahoma, to release the land from the ancient curse spoken by Dragging Canoe more than two centuries before. Perhaps both he and the land are finally at peace.

THE LEGENDARY GHOST
OF THE *DELTA QUEEN*

JESSICA PENOT

The *Delta Queen* is one of the most famous steamboats in the South. It was one of the longest-running steamboats of its time, and it even managed to continue running until 2007. Despite its long history, the *Delta Queen* is silent now. It no longer roams the rivers searching for adventure. It sits quietly docked in Chattanooga, Tennessee, where history lovers can spend the night in its old rooms and imagine themselves transported back in time. Their transportation is made easier by the ghost that wanders the halls of this old boat. The *Delta Queen* is considered by many to be one of the most haunted boats in the United States. It has been featured on television documentaries and has been explored by numerous ghost hunters. All of these sources seem to agree that the *Delta Queen* is haunted and that the ghost that haunts it isn't going anywhere any time soon.

The *Delta Queen* is an American stern-wheel steamboat. The boat was built in 1926 for use in the Sacramento River in California. The boat was designed to be lavish and expensive. It was one of the most expensive stern-wheel passenger boats ever built. It was the queen of the stern-wheel boats, designed to transport the very rich in the complete luxury they deserved. Attention was paid to every detail of this extravagant boat, and for a few years it did exactly what it was designed to do. Until 1940, the *Delta Queen* carried California Transportation Company's guests up and down the Sacramento River in the lap of luxury.

Times change quickly, and when a new highway was built between Sacramento and San Francisco, the *Delta Queen*'s fate changed drastically.

The *Delta Queen*.

People gave up using the *Delta Queen* to travel between Sacramento and San Francisco. It was easier to drive. The *Delta Queen*'s decks became quiet, and it became obvious that the *Delta Queen* needed a new home. World War II created an urgent need for large vessels, and it was pressed into service first as a hospital boat and later as a yard ferryboat, used to entertain the founding members of the United Nations, among other duties.

In 1946, the *Delta Queen* was purchased by Greene Line Steamers for use on the Ohio, Mississippi, Tennessee and Cumberland Rivers. The *Delta Queen* quickly changed hands again, however. Control of the boat transferred many times in the years that followed. In 2006, it was sold again to the Majestic America Line. When the boat was bought by Majestic America Line, it began to move in different circles and was used primarily in the Mississippi River and its tributaries. Although ownership of this luxurious vessel has changed numerous times over the years, the *Delta Queen* earned its place in history. It won numerous steamboat races, and had three presidents walk its floors: Herbert Hoover, Harry Truman and Jimmy Carter.

On August 1, 2007, Majestic America Line announced the termination of the *Delta Queen*'s duties, ending a historic era during which the *Delta Queen* owned the rivers. There were many who didn't want to let the *Delta Queen* and its history go, however. A "Save the *Delta Queen*" campaign was started to preserve the boat. Sadly, the old queen is no longer allowed to travel on

the water because its wooden structure is thought to be a fire hazard, and in 2009 the *Delta Queen* was permanently docked in Chattanooga, where it was transformed into the hotel it is today.

Stepping aboard the *Delta Queen* is like stepping back in time. Although it is stationary, the old queen still holds its beauty, and as you walk through the lavish halls of the old steamboat, you can imagine yourself aboard the steamboat in its heyday, when the rich and famous gathered aboard to cruise the rivers. Although the rooms aboard this boat hotel are small, they are designed to carry you back in time, and they are lovely. In the main hall in front of the rooms, there are large tables and comfortable chairs. Games are stacked up, and the *Delta Queen* seems like a comfortable place to pass a day playing a game or reading a book on the river.

It is appropriate that the ghost that haunts the *Delta Queen* is as important a historical figure as the *Delta Queen* itself. Mary B. Greene, the legendary riverboat captain, is said to lurk in the lovely halls of the old queen to this day. Mary Greene was a very rare woman. When most women stayed at home with the children, Mary defined herself as one of the most famous steamboat captains of her time. Mary was born in 1868 and married Captain Gordon Greene, who taught her everything he knew about being a riverboat captain. Mary lived her life aboard riverboats and raised three boys on the various boats that her husband owned as their boating company, the Greene Line, grew and thrived.

Mary quickly gained the respect of other river boaters. She was gregarious and witty, and she was also a very talented riverboat captain herself. Mary was the first woman ever to be licensed to captain a riverboat and one of the rare few to ever captain a riverboat. Her legendary status comes from more than just her gender. She was a brave and brilliant captain who did things that her male counterparts would never have dared do. Mary is said to have steered through a cyclone and survived an explosion of nitroglycerine. She raised her family on the river and gave birth to a son, Tom, while her boat was locked in an ice gorge. Her image defined an era, and her talent helped turn Greene Line into a success.

When Mary's husband died in 1927, she took over the running of the Greene Line Steamers Company and ran the company as well as any man. During a time when the Mississippi was crowded with steamboats, her business savvy helped turned Greene Line into one of the most successful steamboat companies of the era.

When her son, Tom, bought the *Delta Queen* in 1947, Mary retired and moved aboard to watch her son run the boat. Mary had her own private suite

aboard the boat in room 109. She was always the life of the party aboard the boat. Mary was said to love dancing and entertaining the passengers with her many stories of life aboard a riverboat. She told of her adventures and captured her audience with tales of her bravery.

In April 1949, Mary boarded the *Delta Queen* with her son Tom. She was going to help him captain the boat to New Orleans. Mostly she was there to entertain, but she was ever the captain. Mary died aboard the *Delta Queen* during that trip at the age of seventy-nine. She died on the boat she loved, doing what she loved, and those who know the *Delta Queen* say that she's never left her favorite riverboat. Mary's last son also died aboard the *Delta Queen* a year after his mother, leaving Greene Line in the hands of his widowed wife.

Despite Mary's gregarious nature, she was a teetotaler. She was very firmly against the consumption of alcohol and forbade bars aboard her boats. Shortly after she passed away, a bar was put into the *Delta Queen*. It wasn't long before a tugboat named the *Mary B* crashed into the *Delta Queen*, destroying the bar. Mary's full name was Mary Becker Greene, and it is believed that it was no coincidence that the tugger that destroyed the bar was named *Mary B*. Many believe that this was brought on by Mary's ghost. They also believe that Mary's ghost protects the *Delta Queen* even to this day, keeping it safe from harm and corruption.

There are many stories about Mary Greene aboard the *Delta Queen*. Room 109 is said to be the most haunted room aboard the boat. This is where many passengers have described having paranormal encounters and seeing unexplained things. People have said that the doors bang and close by themselves aboard the old boat. Tourists have even described seeing a phantom aboard the *Delta Queen* that meets Mary's description. They describe seeing an elderly woman in period dress wandering the boat. Unexplained noises have also been heard throughout the boat. Those who have encountered the ghost don't describe being afraid, however. They feel that Mary is a kind spirit whose only purpose is to stay with the boat she loved so deeply in life.

CHILLING CHATTANOOGA HIGH

AMY PETULLA

Schools have always been favorite haunts for ghosts. Perhaps the attraction of many happy memories calls them to linger in those locations. Whatever the reason, Chattanooga's oldest and most historic high school continues this proud tradition at both of its last two locations.

A HAUNTING ON THIRD STREET

Chattanooga School for the Arts and Sciences (CSAS), at first glance, appears similar to many schools built in the first quarter of the century; built in the Colonial Revival style, the imposing brick structure serenely surveys its surroundings. In an effort to get a different perspective, I decided to photograph the school from across the street and was immediately struck by the marked difference in atmosphere brought about by the short passage over the pavement.

On the opposite side of Third Street lie no fewer than three adjacent graveyards: the Confederate Cemetery, which is home to many Confederates and at least two Union soldiers who lost their lives in America's Civil War and which opened its gates to its last denizen in the year 2000, when the body of a long-dead soldier was discovered during a swimming pool excavation on Missionary Ridge; the Citizens Cemetery, which houses the

graves of many early residents; and the Jewish Cemetery, the only one of the three that is still accepting new occupants. A stroll through the central section of the burial grounds simply brings a sense of peace and history; some gravestones leave you wondering at the story that must be behind them, like the one in the Jewish cemetery inscribed, "A Priestess by Birth and Deeds," and some that strike a note of recollection, like the Citizens Cemetery marker of Chattanooga's first postmaster John P. Long, who is credited with naming the city.

The outskirts of the burial grounds, however, are a different story. I was struck with a feeling of overwhelming sadness as I proceeded toward the plot's edge. While the grounds there are neat and clean, many markers are knocked over, worn flat or sunk so deep into the ground that they can no longer be read. The graves are more spread out and less organized. Tombstones have crumbled, a crypt was broken into and a massive oak was uprooted, leaving a body-sized hole right next to a tombstone, as if the resident had given the roots a mighty shove in order to crawl out. Many graves are unmarked. The old potter's field remains undesignated, and many soldiers are memorialized merely by unit. Some sources say

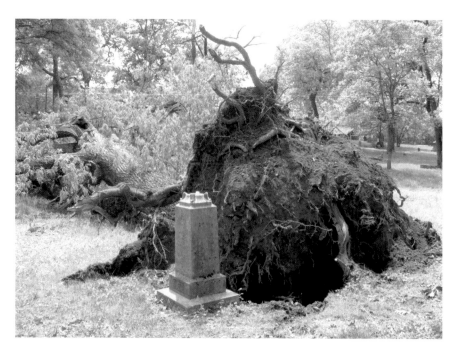

A disturbed grave at Citizens Cemetery.

that as many as 2,500 soldiers are buried there, far more than the number of monuments. During the Civil War, many soldiers were buried in a low, swampy lot near the river; the river rose and fell over them, and markers were lost or marred beyond legibility. In 1867, veterans purchased the Third Street plot for $750 and had the remains dug up, moved and reinterred, but the identities of many were never recovered.

The memorial park is quiet, too quiet for an area lying between two large schools (for it is backed by UTC). While at one time, students played ball there, using the tombstones for bases long ago, no such frolicking of the living goes on at that location now. However, at least one member of the East Tennessee Paranormal Society reports that the shade of a soldier interred in that hallowed ground still patrols the Confederate Cemetery portion of this graveyard. He contents himself with the confines of his eternal home and has not been known to expand his domain to the school but rather, at least according to this member, makes his presence known: "You will leave there with a different view of the paranormal." Perhaps it is simply a question of territory, as CSAS has its own eternal overseers already. A history of the school is helpful in identifying who lurks within its confines and why.

A School System Is Born

The first school in Chattanooga was located in a log cabin near the corner of Lookout and Fifth Streets in 1835. The structure also served as the community center, and in 1838, the area's leaders gathered there and selected "Chattanooga" (which, depending on who you ask, means, "rock coming to a point," "the Big Catch," "draw fish out of water," "Choctaw town," "Eagle's [or Hawk's] Nest" or "difficulty") as the community's name. Later, after that building was gone, the jail that housed the famous Andrews' Raiders was constructed at the same intersection.

A graded public school system was not established until July 18, 1872, when an ordinance was passed to create this more formal educational structure. Henry D. Wyatt was elected as the first superintendent, a position he kept for twenty years. The first public grade school opened its doors to white students on January 1, 1873. Because there was no high school, Professor Wyatt initially taught a few of the older boys who

wanted to continue their education in his office. He sought to rectify this omission when he planned the entire city school system. The system included five schools: the first and third district schools, a small primary school, Howard School for black children and the second district school, which included a high school.

CHATTANOOGA HIGH SCHOOL

The first space for Chattanooga High School was purchased in December 1873 from the Masonic fraternity, and it was opened to thirty-five students on December 11, 1874. Over the next forty-eight years, the location was moved five times, until finding its home in 1922 at its sixth location, between Third Street and Riverside Drive—the building that currently houses the Chattanooga School for the Arts and Sciences. The land for that location was purchased in 1917. The building itself was designed by famous architect Reuben Harrison Hunt, who designed virtually all of Chattanooga's most memorable buildings, including the old Hamilton County Courthouse, the Federal Building, the Tivoli Theater, Memorial Auditorium and the James Building, which at twelve stories was the city's first "skyscraper." Hunt went on to design so many public buildings throughout the South that he earned the moniker, "the outstanding architect of the South."

Chattanooga High School remained in the current CSAS building for forty-one years, all but five of those years under the leadership of revered principal Colonel Creed Bates. Colonel Bates was an incredible leader, unconditionally dedicated to his school and students. The colonel often recited, "You may forget you're a student of Chattanooga High School, but the public will never forget." Colonel Bates loved roaming the school to be among his students. He particularly loved the third-floor library, where he could oversee his pupils hard at work, as well as the auditorium that was later named for him. He remained principal of CHS until 1964.

RIVERSIDE HIGH

In 1963, Chattanooga High School was moved across the river to the site where it remains to this day, a school that is also currently known as the Center for Creative Arts. At that time, Howard High School, Chattanooga's black high school in that era of segregation, was bursting at the seams, so the city converted the old Third Street building to Riverside High in order to house the excess population from Howard. The school was immediately full—when Riverside first opened, it had about two thousand students, almost twice as many as today.

Riverside High was known for having a great basketball team and a great band. The school won the state basketball championship in its division three times. Some exceptional athletes came out of the school, and other students also went on to fame and fortune, including Riverside's most well-known graduate, actor Samuel L. Jackson. The school remained segregated until about 1973, and while it differed in racial makeup from Chattanooga High School, it was similar in the strong attachment the students felt toward the school.

Assistant Principal Roy O. Vaughn, called "R.O." by the kids, epitomized the heart and soul of Riverside. He reminisced about the kids: "Some needed love, some needed understanding, some money for lunch, some a good paddling." Mr. Vaughn loved the young scholars so much that he turned down a request for him to become principal so that he could continue to work closely with the teens. He said that his worst experience was having a student leave the school without permission, only to be killed in a car wreck shortly after sneaking out.

CHATTANOOGA SCHOOL FOR THE ARTS AND SCIENCES

Riverside was closed in 1983 due to a drop in enrollment after desegregation, down to one-tenth of what it had originally been. The old CHS and Riverside High building was used from 1983 until 1985 as Erlanger School of Nursing and Continuing Education and then remained empty until 1986, when it was reopened in its present incarnation, as the Chattanooga School for the Arts and Sciences.

CSAS was the first, and until recently the only, K-12 Paideia school in the country. It was established on the Paideia principles that all children could learn and that children learned in a lot of different ways. Steve Prigohzy was hired as the school's principal. He and his staff had little time, less money and a building they variously described as "nauseating," "depressing" and "dog-ugly," but they had enough motivation and drive to more than make up for those shortages. Mr. P, as he came to be known, brought in an interior designer willing to brainstorm ways to work with money shortages, the need to comply with the fire code and the necessity of preserving history. Money-saving measures included sending the auditorium chairs to Nashville so prisoners could refinish them, as well as rescuing lights that were otherwise on their way to the dump for use in the school. The school's name was going to be Paideia, but no one could pronounce it. Someone said, "You're going to do a lot of arts and sciences. Why not call it that?" And the name stuck.

As a magnet school, CSAS draws students from all over the Chattanooga and the Hamilton County area. Diversity was among its founding principles, and the school strived for years to maintain an equal ratio of students in the areas of gender, race and economic factors, until maintaining that balance was declared "unconstitutional." However, there are always more applicants than spots, as students at Chattanooga School for the Arts and Sciences boast some of the highest standardized grades and post-graduation college attendance rates in the area. The school was added to the National Register of Historic Places in 1986.

THESE HAUNTED HALLS

During the day, filled with light and the laughter and buzz of a thousand students, it is hard to imagine that CSAS is haunted. At night, however, with shadows creeping around corners and only the sound of your footsteps echoing through the halls, the school takes on a much darker aspect. With a glance out the window at the moonlit expanse of graves across the street and the haunted UTC buildings beyond, the disembodied sighs of those long dead become almost audible and the paranormal possibilities seem much more real.

One of the ghosts at CSAS is purported to be Colonel Bates. According to legend, his spirit likes to hang out in the library on the third floor and

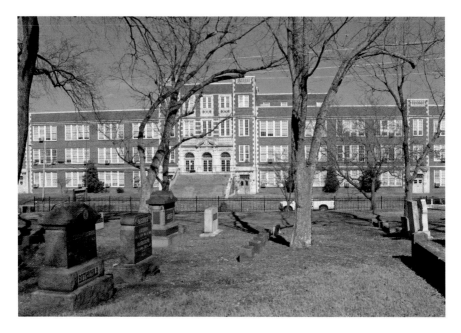

CSAS, as seen from the cemeteries across the street.

sometimes manifests itself as a cold chill. I was able to speak to one person who had experienced this himself. A former custodian in the building says that he would always go to the library at night to turn off the lights. Although the temperature had been normal in the library earlier in the evening, late at night he frequently felt a presence there and would feel a cold chill in a particular spot on many occasions. Sometimes this would occur after he had already turned the light off once, only to return and find it on again, with a chill presence permeating the air.

The same custodian reported that, during the time the building sat empty, before it became CSAS, he was walking down the main hall on the second floor when he heard the sound of children's laughter coming from a classroom just around the corner. The sound continued as he approached, and he decided to investigate, knowing that no children were supposed to be in the school at the time. He approached the classroom that was the source of the disturbance, put his hand on the knob and slowly opened the door, only to find...nothing! There were no children or adults in the room, no audio device playing and no windows—nothing to cause the sound. He looked all around to see if someone might be hiding or if there was a way that they could have snuck out, but there was simply nothing there.

Legend also has it that a ghost has been seen in the hallway near the Creed Bates Auditorium on the second floor of the school. While it is possible, of course, that an errant spirit might be venturing from the cemetery across the street, a more plausible explanation is that the specter of a former student, or perhaps Colonel Bates himself, lonely for the memories and emotions that constitute life, had returned to the social center of the school to try to recapture some of the *joie de vivre* of former days. After all, the most joyful events at the school occurred almost exclusively in and around the auditorium. It has hosted many spectacular events. Bob Hope performed at the school early in his career. Everyone's favorite CHS teacher, Ms. Pryor, put on fifty-three plays, twenty-five stunt nights and at least one circus, for which a live baby elephant and several ponies were brought in. Teens would tell their friends to join them "under the clock" outside the auditorium, which served as the central meet-and-greet, where music was often played. All in all, many strong and pleasant memories have imprinted themselves in and around the Creed Bates Auditorium, and while the clock may be a distant memory, the aura abides still—as do apparitions, apparently.

The final ghost reported at CSAS is associated with the gymnasium. As the story goes, a popular and gifted basketball star who was at the school at the time it was Riverside died, and he continues to haunt the John B. Steele Gymnasium there. It's said that you can still hear him dribbling if you are in the gym late at night. If a basketball star died during the time he was a student there, the name has since been lost, but there is at least one well-known NBA basketball player, Anthony Jerome Roberts of the Denver Nuggets and Washington Bullets, who went to Riverside and died young—as did the Riverside student whom R.O. Vaughn mourned, who died tragically before she had a chance to really live. Perhaps one of them has returned to the place they were happiest in life.

CENTER FOR CREATIVE ARTS

Chattanooga High School was relocated from Third Street to north Chattanooga in 1963. While the school initially thrived at the new location, it gradually lost attendance as the population in the area aged and the number of teenagers dropped. In an effort to revive the school,

it was converted to the Phoenix School, with the theme of rising from the ashes back to its former prominence. Later, administrators decided to add a performing arts "school within a school," which incorporated dance, music and musical theater for the students within the school's zone. This coincided with the decision to build Chattanooga's Tennessee Aquarium, the central factor in the rebirth of downtown Chattanooga. After the aquarium opened on May 1, 1992, the North Shore boomed, but the population was mostly young professionals, so there continued to be a shortage of teenagers. As the performing arts curriculum at the school had proven popular, and as Chattanooga was increasingly embracing its arts community, the school system decided to take a bolder step by eliminating Chattanooga High School's zone and making it a true magnet school, where admission was determined by audition and interview. The result was the Center for Creative Arts—Chattanooga's arts magnet school, which draws the most gifted students from all of Hamilton County.

The arts offerings at CCA were expanded beyond just performing arts to also include fine art and writing. The school has won many state and national awards, most recently garnering national recognition when it received the Outstanding Arts School Award and the outstanding Community Partnership Award with the Chattanooga Symphony and Opera from Arts School Network in 2011.

A FRIENDLY GHOST

Even before it became a dedicated arts magnet school, Chattanooga High School had an auditorium with a full orchestra pit. However, a steep drop off the edge of a stage into such a hole has its risks. While no student was reported to suffer a major injury from a tumble off the brink, one staff member was not so lucky. The school is reported to have had a custodian known as "Old Joe." Old Joe was jovial enough, though sometimes with some artificial help. It is said that during his lifetime, this man was friendly with the spirits of a liquid nature. According to the legend, after imbibing a little too much one day, he fell backward offstage into the depths of the pit and died a painful death. The exact date is unknown, although according to a former student, this occurred in the late 1970s.

The auditorium stage haunted by Old Joe is central to CCA, having been the home to many fabulous shows and elaborate sets. This particular prop rests near the school's entrance, having been recovered from a closing theater; for many who have seen it when attending performances there, it is symbolic of the school and its stage.

Deciding that it posed a hazard, the school covered up the orchestra pit after Joe's death. After its conversion to a dedicated magnet arts school, someone with the Performing Arts Parent Association (PAPA) mentioned the obvious: students at a fine arts school needed an area where its symphony could play unseen during stage productions. When it was pointed out that the school already had one that had been covered, some parents decided to adopt the adage "It is easier to ask forgiveness than permission" and tore out the boards covering the pit. When school personnel objected based on safety concerns, the parent who had initiated the liberation of the pit innocently responded that he didn't have the skills to replace the covering, and that is how CCA reclaimed its orchestra pit.

Joe manifests himself in a couple of locations. Back in the old days, before cigarette smoke was recognized as the hazard it is, the custodians used to hang out near the assistant principal's office and smoke. Reportedly, a strong smell of cigarette smoke can still be detected in that same spot, when Joe is

surveying his domain. As one would expect, however, his favorite haunt is the auditorium stage. According to Victoria, a former CCA student, many students hear footsteps across the stage and see the curtains moving during a study hall in that room, when no one is up there. She states that on one occasion, in fact, the curtains opened by themselves, and the students heard a sound like a janitor's bucket being rolled across the stage.

Victoria also mentioned one other ghost in the neighborhood around CCA that the students sometimes encounter. Usually leaning against a lamppost, "Charlie" is a rather large black man, although his transparent form fails to hide the lamppost. He apparently is not permanently tethered to the post, however, as two young ladies reportedly saw him in their home one evening. According to them, he laid a rose on the mantel and then, like a sigh on a breeze, faded away before their eyes. He has not been seen as much of late, so it could be that giving that floral tribute was what he had been waiting around for all those years and that accomplishing his task finally allowed him to find peace.

As to Old Joe, perhaps he is simply letting his objection to the reopened pit be known.

THE GHOSTS OF CHICKAMAUGA

JESSICA PENOT

Chickamauga Battlefield sits quietly just south of Chattanooga. It is a lonely stretch of grass that whispers of history. It is a peaceful place. The landscape is dotted with monuments and cannons that serve as reminders of all of the terror that once took place on this bloody battlefield. One of the largest battles of the Civil War was fought in this now tranquil place, and many believe that the battlefield is still thick with the ghosts of the past. The Haunted America Tours website notes that Chickamauga is the second most haunted battlefield in the United States and that Gettysburg is the only other battlefield that has more ghosts.

More than ghosts haunt the battlefield, though. Legends older than battles stain the grass at Chickamauga. Those who know the battlefield also speak of a monster called Old Green Eyes that comes out at night. No one is sure what Old Green Eyes is. Some say that he is a demon, and others say he is an "elemental." Whatever he is, Old Green Eyes is older than the Civil War.

The Battle of Chickamauga was the largest Union defeat of the Civil War. Outside of the Battle of Gettysburg, it had the highest number of casualties in the Civil War. The battle was fought between the Union Army of the Cumberland under Major General William Rosecrans and the Confederate Army of Tennessee under General Braxton Bragg. The battle was named for the West Chickamauga Creek.

In 1862, the Union army under Rosecrans was directed by President Lincoln to push the Confederates out of Tennessee. After Rosecrans's successful Tullahoma campaign, he seemed well positioned to take Tennessee.

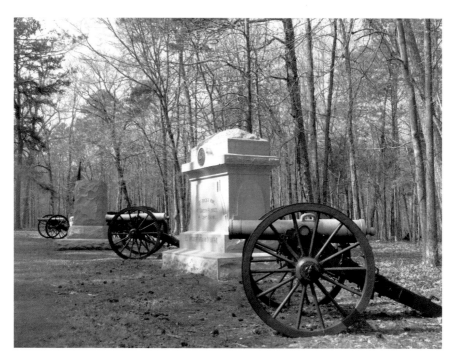

Chickamauga Battlefield.

Rosecrans was reluctant to comply with Lincoln and requested both more troops and more time. Under continued pressure from the president, in September 1862 General Rosecrans forced General Bragg's army out of Chattanooga and claimed the city for the Union forces.

General Bragg then lured the Union troops out of Chattanooga to the Chickamauga site. He was determined to defeat the Union forces and retake Chattanooga. On September 17, his men met the Union forces, who were heavily armed with Spencer repeating rifles. Bragg was unable to break the Union line. On September 19, Bragg's men began an intense assault of the Union line, but they were still unable to break it. Late in the morning of the nineteenth, Rosecrans was told that there was a gap in his line. Rosecrans responded to this deadly misinformation and moved units in to fix the gap and in doing so created a genuine gap in the line.

The Confederates seized on the opportunity. Led by Lieutenant Longstreet, the Eighth Brigade pushed through the gap and was able to drive one-third of the Union army from the battlefield. The Confederates then barraged the split Union forces with assaults, but the Union soldiers

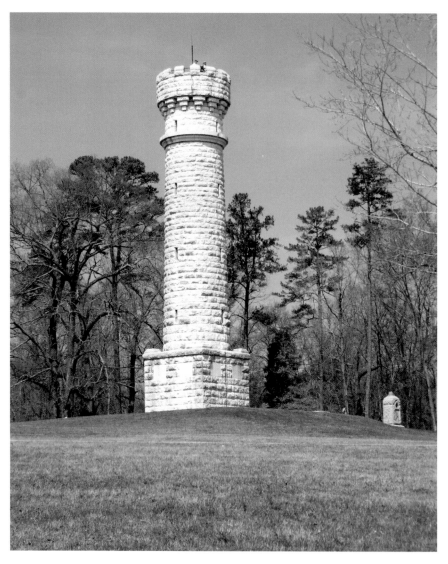

The Tower.

held on. At twilight, Union forces retreated to Chattanooga. Confederate forces then besieged the city. The Confederates had won the Battle of Chickamauga, and they didn't want to lose their advantage. Ultimately, the Confederates would lose the following battles for Chattanooga. General Ulysses S. Grant would drive the Confederates from the area, and General Sherman would use Chattanooga as a staging ground for his infamous

1864 march on Atlanta. However, the Battle of Chickamauga stands as one of the South's greatest and costliest victories.

Thirty-five thousand men died on the blood-drenched grass of Chickamauga. Some say that Chickamauga actually means "the river of death" in the upper Cherokee tongue. They say that this was the place where many of the old Cherokee contracted smallpox and died and that its name comes from this massive loss of life. The origins of the word are murky, and there is much dispute over them, but "river of death" lingers in the mind as a strangely appropriate name for this haunted battlefield.

After the dust had cleared the battlefield and the soldiers had left to fight for the city of Chattanooga, the battlefield was left in a quiet night. That night, the women came with lanterns. They came looking for their lost loves. They came looking for their husbands, sons, brothers and fathers. Their weeping filled the night. Many say that these lights still linger on the battlefield and that the nights are filled with ghostly lights and the sounds of weeping women. Local legend also describes a very famous white lady ghost who wanders the battlefield at night searching for her lost fiancé.

Like other Civil War battlefields, it took months to clean up the legions of dead that fell onto the field. The corpses remained where they fell, rotting. This began a long association with the Chickamauga Battlefield and the bodies of the dead. Those who describe paranormal encounters in the park often report seeing corpselike ghosts. The Civil War soldiers weren't the last to die here, either. Long after the Civil War, a camp was built on the Chickamauga site to train men for the Spanish-American War. The camp wasn't there long, but disease and death riddled the camp for its brief stay. Legend tells of the many suicides on this old field and that murderers have often dumped the bodies of their victims to rot in the quiet green field. Death stays with Chickamauga and has become its constant companion.

Those who have been to the battlefield at night describe a multitude of paranormal encounters. They describe the famous lady in white crying out for her lost love. They describe the ghostly lights. They report the sound of phantom hooves and strange cries in the dark. They say that they've seen the ghosts of dead soldiers and dying soldiers. There are as many stories as there are visitors to the park, because when night falls on Chickamauga, the dead seem to come to life.

However, it isn't the ghosts of the dead that hold the most interest for paranormal explorers of this old battlefield. It is Old Green Eyes himself that brings them. Old Green Eyes is utterly unique to this area, and his

legend permeates the battlefield. The most prevalent legend says that he is a monster who has been at Chickamauga all along. According to those who believe this legend, he was seen at Snodgrass Hill after the Battle of Chickamauga. He has glowing green eyes and terrible jaws with fearsome teeth. He has a humanlike appearance, but he is more monster than human. Many visitors and some rangers describe encounters with this fearsome monster and describe him as horrifying to behold.

Although most of the current park rangers are reluctant to talk about the supernatural elements in Chickamauga, many of the older park rangers were very happy to discuss the things that wander the park at night. Their stories can still be found everywhere as reminders of the terrible things that lurk in the shadows of the park at night. They tell of encounters with terrible Old Green Eyes and the ghostly ladies that wander the night.

Chickamauga Park is now closed at night. Visitors who come during the day are greeted by a peaceful park where children can play, and in the beauty of the spring sun, you almost forget that anything dreadful has ever happened in Chickamauga. The park closes, shutting off explorers to the darker side of Chickamauga, but the stories remain, reminding us that the "river of blood" still runs through this park, tying it to old death and new horror.

THE BLACK AGGIE AND BOGEYMAN OF MEMORIAL CEMETERY

AMY PETULLA

Cemeteries are naturally a favored location for things that go bump in the night, and Chattanooga's memorial parks are no exception. The most well-known haunted necropolis here is the Chattanooga Memorial Park, aka White Oak Cemetery but also sometimes known locally as the Red Bank Cemetery or the "duck pond cemetery." There have been a number of tales associated with this graveyard, but the most famous concerns an arch monument in the middle of the cemetery. The arch is inscribed with "F. & A.M.," which stands for "Free and Accepted Mason," but no one is sure of the origin of this arch, and even employees of the burial ground deny knowledge of its roots. A dark figure has often been reported to hang out near that arch.

Many people call the ghost a "Black Aggie," meaning a dark figure that generally appears in graveyards, without any apparent consciousness, and that repeats the same actions over and over (in this case, appearing in the archway). The origin of the phrase appears to be a famous grave monument by that name that was said to come to life at night and haunt its eternal home in a variety of ways. That statue (which was a pirated copy of the monument known as *Grief* commissioned by the grandson of President John Quincy Adams to mark his wife's tomb) served for decades as the gravestone for General Felix Agnus in the Druid Ridge Cemetery in Baltimore. Owing to its fame, it was donated to the Smithsonian and then to the National Museum of American Art, was lost for several years and was eventually discovered at the Federal Courts Building in

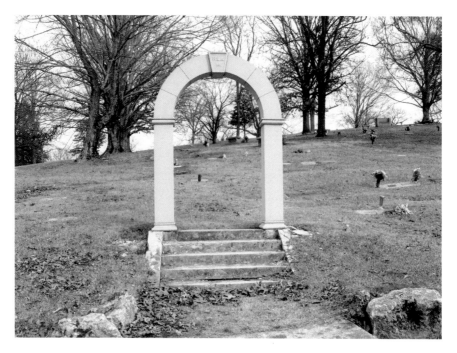

The most famous haunt at Memorial Cemetery.

Washington, in the rear courtyard of the Dolly Madison House, where it remains today.

While no one is certain of the origin of the shadow man of Chattanooga Memorial Cemetery arch, there is no lack of speculation. The most common theory is that it was the fervent desire of a particular Chattanooga gentleman that, upon his death, an archway be constructed over his grave to provide him with an eternal memorial and resting place that would stand out among all the rest. He went to his grave believing that his wishes would be carried out, but once the man was deceased, his family was no longer reluctant to share their mutual opinion that an archway placed directly over his grave was ridiculous—they therefore modified the arrangement to suit their own wishes, placing the arch as an entrance to their family plot instead, so that at least they could all benefit from it. Perhaps the man's spirit was so chagrined at this flagrant disregard of his instructions that he has not been able to move on, but instead he remains to haunt the arch he so desired, ensuring that none of his detestable family members would enjoy the spoils of this intolerable plot to ignore his final wishes.

Many paranormal researchers have explored the activity surrounding the arch on a number of occasions. During one group's investigation, members left a video camera recording near the monument. The investigators at first got quite excited upon reviewing the film, which showed the camera actually moving around. However, review of a tape made with a second camera revealed what was actually happening: a coyote was attacking the first camera! The film was good for more than just its humorous aspect, however. It shows the creature startle and look at the arch. Right at that moment, a mist shot across the screen. Then the animal looks away, the mist occurs again and then he looks and startles again—clearly having decided that he wanted no part of whatever was causing the mist, he wanders off. The mist is only on the screen for exactly thirteen frames in each occurrence, whereas a standard video is thirty frames per second, so it would have been very difficult to spot with the unaided eye.

At least one ghost hunter believes that he has more details about the specter of the arch. Paul Cagle, author and cofounder of South East Paranormal Society (SEPS), has investigated the site several times and says that the arch is haunted by the shade of a Civil War general. He maintains that his group took a photo of the grave that revealed a pair of red lights, like eyes, floating above the arch.

Mr. Cagle's photo is not the only one in this cemetery that has stirred up excitement. On April 13, 1934, the *Chattanooga Banner* ran a photo of what appeared to be a ghostly couple in wedding clothes, accompanied by a story claiming that Claude and Emma Tyrone died in a hotel fire on their wedding night on April 14, 1887, were buried at Chattanooga Memorial Park and appeared there every year on their anniversary. The photo was the talk of the town until early the next year, when it proved to be a fake. Perhaps the fact that the cemetery was not opened until the 1890s helped spur on the investigation. The city took the deceit to heart to such a degree that the author/photographer was indicted and plead guilty to chicanery. That has not, however, done anything to dispel the legend that the cemetery is occupied by more than dead bodies.

The last tale of the park's supernatural residents is an account of an employee who was followed or chased through the property. This story has been reported to me in two different ways: one as something that occurred many years ago, with a more aggressive entity, and one of more recent times, involving a spirit more curious than furious.

According to the earlier version of this legend, the tale centers around an old oak tree next to the information building at the front of the park. A

groundskeeper or security guard who had been employed there for more than twenty years was working very late one night in the building when he heard something moving around outside. He went out into the darkness and shone his light on the tree, which seemed to be the source of the sound. According to the legend, the guard saw a two-and-a-half- to three-foot-tall being, humanoid in appearance, laying in the branches and staring at him. The guard fled back into the information building and locked the door behind him. He collapsed against the door, panting, and stayed that way for several minutes, while trying to convince himself that what he had seen was not real. Finally, when his heart stopped its jackhammer rhythm and his thoughts had calmed, he told himself that it must have been a figment of his imagination. After all, he was no longer hearing any sound coming from the tree. After a few more minutes, he plucked up his courage and returned outside. He examined the tree and breathed a sigh of relief upon realizing that the creature was no longer there. His relief was short-lived, however, because in the next instant he saw that, in fact, it had descended to the ground and was crouched only feet from him. He did not need a second look to get his feet in motion, and he took off running at top speed. The creature gave chase and pursued him all through the cemetery, menacing him with every glance he snuck. He didn't stop until he returned to the front and reached the street. According to rumor, the man returned to the cemetery with the sun and quit that day, never to return. They say that he swore until the day he died that this happened.

The alternate version of this story also involves a groundskeeper who was followed, but it was a black shadow, similar to the one at the arch, and rather than chasing the groundskeeper, the shadow followed him at a distance as he traversed the grounds during his work, simply watching. The shadow would duck out of sight while he ascended each hill and then peek over the crest as he descended the other side. It followed him all the way to the very back quadrant of the cemetery but did not attempt to approach. The spirit did not seem intent on attacking, but the groundskeeper, according to the myth, was sufficiently spooked to seek new employment among the living.

THE ANGRY GHOST OF THE READ HOUSE

JESSICA PENOT

The Sheraton Read House in Chattanooga is an unassuming hotel. It occupies a quiet corner in downtown Chattanooga. It is surrounded by the sounds of passing cars and pretty trees. The hotel's history can be seen in its façade, and it feels immediately inviting and warm. But despite its beauty, a dark history lurks beneath its quiet exterior.

The Sheraton is an old hotel, and its history is older than the building in which it stands. The Read House was originally opened as the Crutchfield House in 1847 by Thomas Crutchfield. It was designed to cater to those traveling between the Atlantic and Western Railroad lines. The inn was built directly across from the new rail terminal, and when the trains arrived in 1850, they brought a boom in business for the Crutchfields and for Chattanooga. The Crutchfield had a golden period and prospered for ten years. In 1861, everything changed.

Jefferson Davis stopped at the Crutchfield on his way home from the Senate in 1861. He stood in the lobby of the hotel and told everyone that he had left the Senate, and he spoke of plans to secede from the Union. Thomas Crutchfield was a Loyalist and was irate. He jumped up on the counter and declared Jefferson Davis a traitor. A fight broke out in the lobby of the Crutchfield. Guns were drawn, punches were thrown and things happened that make the political debates of our times look like play. Bloodshed was prevented when Crutchfield's son dragged him from the room.

Thomas Crutchfield sold the hotel after this, and it wasn't a moment too soon. After Union forces took Chattanooga, the Crutchfield Hotel was

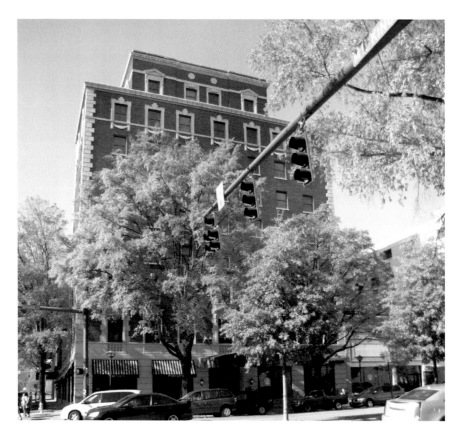

The Read House.

converted into a Union army hospital. For years the hotel bore witness to all of the horror of the Civil War as the bloodied and dying were pulled off the battlefield and brought to the Crutchfield for medical care. The blood of Union officers stained the floor of the once lovely hotel. Yet the Crutchfield survived the Civil War, only to burn to the ground in 1867.

The Crutchfield's story could have ended here, but a prominent businessman saw promise in the ashes of the old hotel, as well as in the location. In 1871, a doctor named John T. Read and his son, Samuel, began to build a new hotel on top of the Crutchfield ruins. They opened the new Read House on New Year's Day in 1872. The hotel grew in name, and more and more travelers came to town to stay at the well-known Read House.

In 1926, the hotel was redone in elaborate Georgian style by the famous architects Holabird and Roche. The hotel became a ten-story architectural

landmark and a thing of profound beauty. The Read House was lavish, with marble floors and walnut paneling. Waterford crystal chandeliers shed dancing light across crystal ballrooms, and people came from all around to bask in the beauty of the historic Read Hotel. The dark past of the Crutchfield was almost forgotten.

Perhaps the dark past would have been forgotten entirely if the ghosts of these times weren't so active. Their long shadow serves as a reminder of bloody battles and untimely deaths. The most famous and notorious haunting of Read House is in room 311. According to local legend, a young woman by the name of Anna Lisa Netherly was murdered in this room. Ms. Anna was a lady of the night. A local soldier, wanting for female companionship, bought a few hours of Ms. Anna's time. The soldier was a Union soldier, and he went all out and got a room at the Crutchfield Hotel. Anna happily went with the soldier in 311, and the two spent several hours doing the things that young men and prostitutes do. No one can know for sure what happened after this. There are so many stories that it is hard to keep up with them all. For some reason, the young soldier and Ms. Anna had a disagreement. Tempers soared and yelling began. Before Anna knew what was happening, the young soldier had slit her throat and left her dead on the floor.

There are other stories about Ms. Anna. Some say that it was her jealous husband who killed her, and others say she killed herself, but the story I've heard the most is about her and the young soldier. Whatever the case, Anna's ghost didn't die with the Crutchfield. Her spirit lingered with the ashes of the old hotel and rose up to take a position in the new Read House. Stories of her ghost are thick there. There are so many stories that it is hard to sort out the truth. Some say that the ghostly activity was so hostile and terrible in room 311 that it was closed down and turned into room 313, which was then converted into a storage closet. Others say that 311 is still 311 and that if a smoker goes into this room the ghost become furious and starts throwing objects.

I went up to room 311 and saw no evidence there to support or disprove any of the rumors that surround this very haunted room. It was quiet and dark, and all of the guests seemed happy. It is hard to say what has really happened in or to room 311, but one thing is sure: those who have seen Anna's ghost say that she is angry and that whatever happened there just hasn't gone away.

THE GHOSTS BENEATH THE CITY

JESSICA PENOT

Dr. Jeff Brown had heard the rumors. He had heard what people whispered about. In Chattanooga, there were mysterious stairs that led nowhere. There were windows that appeared to creep out of the street. There were arches that had been bricked up. Throughout the older portions of the city, it was as if something dark lurked beneath the street that had been hidden away. People knew that something was hidden beneath the streets of Chattanooga, but no one knew what. It was Dr. Jeff Brown, an archaeology professor at the UTC, who set off to find the hidden history of Chattanooga, Tennessee.

In 1867, Chattanooga experienced a flood worse than any it had ever known. It started raining, and four days later it was still pouring. Fear trickled through the city as citizens watched the Tennessee River begin to rise. It rose slowly. It crept up out of its banks and through the terrified town. It cut off the city by washing away bridges, and finally it devoured the city. The Tennessee River rose fifty-seven feet and took Chattanooga with it. Houses were carried downstream, the rail yard was submerged and the entire downtown became part of the Tennessee River. Bloated corpses drifted by on the current, leaving evidence of those who had died in the flood. The water carried death and destruction with it, the city was helpless to stop it and still the water continued to rise.

Despite the death and darkness that swirled around them in the ever deepening waters, the residents of Chattanooga weren't defeated. Chattanooga had just survived the worst the Civil War had to offer, and it

Underground Chattanooga.

wasn't going to have its spirit crushed by a little water. One entrepreneur saw the opportunity in the water and went with it. This entrepreneur decided to make the most of the flood and took a boat into the Read House Hotel. He took the boat in and came out with a load of guests who had been trapped in the hotel. He began taking travelers and residents alike on tours of the water logged city. His tours showed people wonders and horrors, and for a brief moment in time Chattanooga became like Venice, Italy. People traveled by boat and adapted to the unstoppable forces of nature.

The waters dried up and life went on. But Chattanooga wasn't spared for long. In 1875, another flood came, and the waters of the Tennessee River rose again. More death and destruction followed. The city was beginning to feel like the suffering of Job had been flung upon them. Finally, in 1886, another flood came with such a fury that a one-hundred-foot warehouse was carried away in the current. Even the most resilient residents became overwhelmed after sights like these. The city decided that something had to be done to exhume Chattanooga from its watery grave. The mayor, working with an industrial engineer, came up with a radical scheme. Since they

couldn't get rid of the water, they decided to raise the city above it. They decided to raise the street level of Chattanooga, Tennessee, by ten to twenty feet. They went to work and accomplished this task, leaving the dark waters and half of the city beneath the new streets of Chattanooga.

Oddly, history has somehow forgotten all of this. No one bothered to document it well, and as time went on, the events of 1875 were almost completely forgotten. If it wasn't for the curious archaeologist, Dr. Brown, no one would have ever known why there were staircases to nowhere or why there was a labyrinth of tunnels beneath the city that went nowhere in particular. The knowledge of these things might have been forgotten entirely.

Unearthing the story of underground Chattanooga dug up more than just history. It also unearthed the ghosts of the old floods. Many people died in the floods that once plagued Chattanooga, and some of them still remain, walking the streets that they once called home. The Chattanooga underground has become one of the most popular stops on local ghost tours, and visitors to the areas toured have seen a multitude of paranormal events. They've seen ghosts in old-fashioned clothing. They've taken photos with strange mists in the picture, they've heard noises and voices and a few people have even been grabbed. One person on the ghost tour even had marks left on their arm from where a phantom had grabbed him.

It is easy to forget what has come and gone before us. History can be washed away, and the forgotten history of Chattanooga's flooded underworld serves as a reminder of this. However, even when we forget, the ghosts of the past linger on; even if you don't fully understand them, they are always willing to reach out to you. Sometimes when they reach out they leave a mark to remind us of what we've forgotten.

THE QUARRY GHOST

JESSICA PENOT

On the side of a mountain, beside a sprawling cemetery, there is a small lake. The lake is easy to miss. It is small, and to the casual observer it looks more like a pond than a lake. The lake is located across from the cemetery, and once you find it, you won't easily forget it. It is beautiful. It is a picture taken from a postcard. It is surrounded by tall trees that lean toward the water. The water in the quarry is glass, and the trees are reflected on its surface. The quarry is quiet, and the sound of birds and the wind rustling through the trees turn into a kind of music in the silence. It is the type of place where you want to sit and enjoy the peace.

The quarry is located across from Greenwood Cemetery and is what is left of an old bauxite mine. In 1910, the mine was still in use. Bauxite is an ore used in the manufacture of aluminum. When the miners were at work one day, one of the workers was using a steam shovel to help in the mining process, and the shovel hit an underground river. The river flooded the entire mine, turning it into the glassy lake that can be seen today. Beneath this lake's placid surface, the underground river still flows. The river's currents are treacherous, and people who have swum in the old mine say that the waters are riddled with currents and undertows that have dragged untold numbers of swimmers to their deaths.

One gentleman I spoke with told a terrifying tale of danger in the old mine. He says that his father and brother were swimming in the mine when the younger brother, who was only four, was pulled beneath the surface of the lake by a current. The older brother dove in after the younger.

The old quarry.

He freed his brother from the current but struggled against the relentless waters until he almost drowned as well. He broke free but barely survived the terrible waters of the old bauxite mine. According to legend, these two brothers were part of the lucky few. Many more haven't survived the currents, and the bodies of the dead are pulled into the underground river, never to be seen again.

One of the most well-known legends from the mine is the tragic story of a young woman. She was a famous beauty, and the man who married her was considered lucky. When they were first married, the couple was happy and prosperous. The sun seemed to shine on their fate, and both husband and wife were completely content. Sadly, the couple's happiness was short-lived. The young woman contracted polio before she turned thirty, and her health steadily grew worse and worse with each passing year. Her beauty faded and her body failed. She was confined to a wheelchair. Unable to walk or care for herself, her care and that of the household was put entirely in the hands of her husband. Her husband loved her, but the pressures of her illness slowly wore away at his strength until he began counting the days to her death. He began to see her only as a burden and dreamt of being free of her.

The young man took his sickly bride for a walk by the old bauxite mine on a sunny day. She was happy to get out of the house and glad for the fresh air. She sat in the sun and looked out over the lake. It was when she was at her happiest that her husband gave her wheelchair a push, and she went rolling into the lake. Once the chair hit the water, she was lost. She didn't have the strength to fight the current or even to swim. She was quickly pulled into the dark water with her wheelchair. She died alone.

It is the ghost of this tragic young woman that is the most famous spirit to haunt the bauxite mine. Many have described seeing her. She often appears to visitors of the mine. She is a lady dressed in white and is seen to hover above the water. She is lovely and drifts across the water in a kind of mist. When her feet touch the land, she begins to fade, and where she walks only wheelchair marks are left behind.

Visitors to the old bauxite mine have described seeing a multitude of ghosts. This lady of the lake is not alone. Other visitors have described seeing colored orbs and hearing voices crying out into the night. Many claim to have seen a glowing green light below the pond's deceptively smooth surface. Visitors often describe seeing the wheelchair tracks beside the water where the lady was pushed. The old mine is filled with ghosts, and just beneath the calm surface of the water, death and sorrow wait for those who are brave or foolish enough to enter.

THE TENNESSEE RIVER SERPENT

AMY PETULLA

The Tennessee River winds sinuously through Chattanooga and is an inextricable part of its history. Before the coming of the railroads, the river was the primary route for commerce and trade, though it was difficult to navigate because of shallows, rocks, rapids and whirlpools. The construction of the dam at Hales Bar in 1913, and later the Nickajack and Chickamauga Dams, made navigation considerably easier, increasing commercial boat traffic. Although the railroad and, later, the highway system provided even more efficient alternate routes, barge traffic continues to flow through the river and the lock at Chickamauga Dam. The waterway these days is just as important to Chattanoogans as a tourist attraction, providing a scenic backdrop for the Tennessee Aquarium and a pathway for a host of water-based attractions, from the *Southern Belle* riverboat, the *River Gorge Explorer* speedboat and Chattanooga Ducks to the numerous white-water rafting companies in nearby Ocoee. It also serves as the host location for many festivals, from River Front Nights to Chattanooga's nine-day annual music festival, Riverbend.

Living up to its best traditions, the folklore of Chattanooga has not left the river untouched by the brush of the supernatural. According to legend, the Tennessee River is haunted by its very own version of the Loch Ness monster.

An article published in the *Chattanooga Daily Commercial* on July 2, 1885, quotes not one but several witnesses who encountered this remarkable example of cryptozoology. The creature—which we'll call "Phoenix"

The river serpent on the Coolidge Park Carousel. The ride's fanciful creatures were all carved at Horsin' Around, until recently the only carousel carving school in the country, located in Chattanooga suburb Soddy Daisy.

for the sake of simplicity—was reported as early as 1820, by Native Americans who traveled the river. At the time, the river had substantial undergrowth that, like the abundant vegetable matter in Loch Ness, rendered the water dark and shadowy, making it difficult to see into the depths. Thus, when the serpent emerged from the depths, it was doubly frightening, as it was completely unseen and unexpected until it emerged, often within a few feet of a canoe. Phoenix was described as being twenty to twenty-five feet long, with a two-foot-long head similar to that of a dog and with a "livid and contorted countenance and frothing lips." When it swam, a one-and-a-half- to two-foot-high fin was reported to protrude from the middle of its slime-coated, two-foot-wide back. One witness stated that the creature had a yellow belly and a blue back. Phoenix was said to be capable of traveling the river at very high speeds when disturbed, so fast that it could cross the river from side to side within a minute. Some described its movements as "serpentine." The creature was reported to be shy for the most part, although occasionally playful,

but not aggressive. It tried to tip over the canoes of some travelers but was never reported to try to harm or eat the people in the boats.

In addition to various unnamed witnesses, the newspaper quoted six people by name who had seen the monster, all of whom, it asserted, were known to be truthful and reliable people, including one who was the father of a judge. It was reported to frequent Harrison, though it traveled between there and Dallas, a portion of Hamilton County that at that time was the county seat. Although the creature did not try to attack any of the witnesses, it was thought to have supernatural powers by which it inflicted harm, for many of those who had laid eyes on it died within the year. As time went by, the creature was seen less often, and the witnesses were more likely to survive beyond a year; it was speculated this was due to the fact the creature was weakening or fleeing the area because large boat traffic was increasing.

Swimmers should not be deterred from the river on account of Phoenix—as mentioned, it is a placid creature, and though my family and I have swum in the Tennessee River many times, we have yet to encounter it. I have not found any newspaper articles within the last century about this particular animal, although occasionally a writer may still mention the Dakwa, a giant soul-sucking fish that the Cherokees believed inhabited the river near the Suck (whirlpool) of Suck Creek. Perhaps that legend was inspired by the gentler beast reported by the *Daily Commercial*.

THE HAUNTED HALLS
OF HIGHER EDUCATION

AMY PETULLA

Surrounded by graveyards, chapels and churches, the University of Tennessee–Chattanooga campus provides a spot where spirits can feel right at home, and according to legend, many ghosts have taken sanctuary there. Founded as a private school by the Methodist Episcopal Church in 1886, it was known as Chattanooga University until 1889, when it was merged with the East Tennessee Wesleyan University at Athens. The name was changed to Grant University, after the U.S. president. In 1907, the name was changed to the University of Chattanooga, which remained until 1969, when it was converted to a public school, was merged with Chattanooga City College and became a principal campus of the University of Tennessee system, under its present name.

Some of UTC's many ghosts are well known and some deeply hidden. An exploration of the campus will familiarize us with their haunts. Unfortunately, we cannot visit "Old Main," for years the campus's only building, as it was torn down in 1917. Before that time, however, it contained classrooms, housing for students and faculty, kitchen and dining facilities, the chapel and the library. It has, however, been replaced by several new buildings, a few of which house the spirits we seek. Let's take a tour around campus to visit with some of them.

Our first stop is Hooper Hall, constructed in 1916. We are surrounded primarily by offices, as Hooper Hall is currently an administrative building. It is also, however, home to the campus's most well-known ghost. John Hockings, a former groundskeeper, adopted Hooper Hall as his permanent

residence in 1974, when he committed suicide by chemical inhalation there. He wafts by us as we explore, leaving a cold chill in his wake and creating sounds in empty rooms. His tale has been well and truly told many places, so we will not disturb his slumber further. Suffice it to say, he has not yet found his eternal rest. Some not familiar with all of the details of UTC's other hauntings attribute all supernatural activity at the campus to this wraith, but John would have us know that is not the case. Let's take the elevator—John enjoys sending it up and down without need of human touch. As we leave, we overhear some of the staff speaking in hushed tones about their experiences with the walking dead here.

We cross directly into Danforth Chapel, built in 1952. As we peer about in wonder at the lovely flower window at the top of the chancel, the small oak pews filling the tiny space, and marveling that this would be the perfect spot for a small wedding, we hear the faint sighs of a woman in the accoutrements of a bride but with an expression of despair that belies her outfit. It seems this sorrowful lady will never hear the sound of a horse and carriage pulling up to take her and her bridegroom away, as she was instead jilted at the altar. Rather than return to the world to face humiliation and a life without her beloved, she chose instead to take her life and remain eternally in this little chapel, hoping that perhaps he may someday return to fulfill her dreams. Let's leave her to mourn in peace.

Perhaps hopeful that her bridegroom has been merely misdirected, Danforth's bride now and then slips down the hall to the lovely Patten Chapel, dedicated in 1919. Bigger than Danforth, Patten is often used for weddings, though a few superstitious brides refuse to be married in a place of worship reported to house two spirits of very different demeanor, fearful that a quarrel between the two could result in disaster.

One, a gentle monk, in a moment of overwhelming despondency, forgot his vows and took his own life and is doomed to spend eternity in the bell tower, where he is said to have hanged himself. The other phantom, though, is the antithesis of gentle. Though the report of his presence here is deeply buried and hard to find, it is said that at least one person has reported that his visit to UTC's Patten Chapel was cut short by the swearing and cursing of a very angry Indian ghost. Imagine touring this peaceful chapel, perhaps trying to plan a wedding, only to be interrupted by a furious spirit whose language definitely did not belong there. It is not hard to guess who the ghost might be, though how he might come to be in such an unlikely place is unknown. The most famous angry Indian ever to occupy Chattanooga was Dragging Canoe, a fierce warrior in life

The Patten Chapel bell tower, said to be haunted by the ghost of the monk who hanged himself there.

who devoted himself to the death and destruction of the white mongrels invading Indian land. His story is told in more detail earlier in the book. But he had, after all, invoked a curse on the land while he still walked the earth, one that could be drawing him back in death. It is my favorite ghostly report at the university, so I'm glad we've dropped by, hoping that he might appear. In death as in life, however, he has no desire to cooperate with anyone of European descent unless their aim is the destruction of other white invaders, so I am disappointed as he sulks in silence.

As we listen, we hear a woman's scream coming from Brock Hall. Many strange noises and voices have been reported coming from the building, which rests on the site of an old jail. Even more sinister is the adjoining lot, whose spirits are said to have adopted Brock as their asylum, after the math building they previously occupied was torn down. It seems that this lot first housed the execution yard for the jail and, most recently, the math department, but in the span betwixt those two, the building served as home to the medical college when the school was Grant University. You object that a medical school is not particularly sinister? Ah, but you haven't heard the whole tale. Let's sit here a moment while I relate it to you.

The medical school held a morgue in its basement to store the cadavers used for dissection. But these cadavers were not voluntarily donated by their former occupants. Instead, the bodies had been dug up under cover of darkness from the paupers' graveyard at Citizens Cemetery on the edge of campus. Enterprising ghouls could glean twenty-five dollars for a whole specimen or divide it into parts to sell to the medical students for five to ten dollars each. Complaints that the bodies of the poor and unknown interred there were being robbed from their resting place were ignored, until the night of November 17, 1894. Suspicion was aroused when former assistant county sexton John Hurst was spotted lolling idly around the cemetery that evening. Over the next two days, it was discovered that the bodies of a man named Moore, buried on October 28, and Charlie Goven, buried on November 17, had been dug up and taken. When Hurst and another man were charged with grave robbing, the medical college folks claimed that they knew nothing about it, yet the very next week, the school's Dr. W.C. Townes publicly proposed that a law be passed allowing the bodies of the poor who would otherwise be buried in this potter's field to be instead "distributed among the medical students."

The subsequent investigation and trial implicated medical students and a few prominent doctors in the conspiracy, and it came to light that the practice of grave robbing was so widely accepted here that doctors and students

from Atlanta and Nashville would get their bodies from Chattanooga. A witness estimated that 90 percent of the graveyard's bodies had been stolen. It also came out that the county sexton, whose responsibilities included grave digging, was part of the conspiracy and had, in fact, begged bereaved family members to let him bury their dead in the potter's field rather than the private cemetery that was the original destination. Because grave robbing at the time was just a misdemeanor carrying penalties similar to that of traffic offenses, however, the miscreants got off with little or nothing in the way of punishment. Many believe that the sounds heard in Brock Hall are the victims of these thefts, crying out for retribution.

Wandering in the quaint and gracious neighborhoods off campus proper, we give a wide berth to the Severance Mansion at 1007 East Fifth Street. The residence was the subject of a 1998 lawsuit in Judge Mike Carter's Hamilton County General Sessions Court. It seems that when the landlord sued his tenants for unpaid back rent, their defense was that the house was unlivable because the landlord insisted on keeping the house at ninety degrees, due to "negative energy and spirits" in the boiler room. The landlord denied this, although he acknowledged that two blessings had been performed on the house. According to the tenants, the "blessings" consisted of nine women in a circle performing a ceremony first to evict the spirits on the first two floors and, a few months later, to exorcise the demons that had moved to the top two floors of the four-story mansion. After a lengthy hearing, the judge sided with the tenants in the matter. Time to veer away from all this negative energy and head back to campus.

Let's end our journey at the library, where documentation of the findings of two ghost investigation groups can be perused. During a 2008 investigation of Patten Chapel by the Tennessee Paranormal Investigative Team, some of the folks in attendance saw a shadow figure running all around the chapel, down the side aisles and between the pews, for a long time. In addition, one team member was pushed while in the bell tower. Perhaps our angry warrior had a hand in bringing about the hanging in that tower that left him with (possibly unwanted) company in his spiritual home. A loud unexplained bang was also captured on tape in Hooper Hall that night.

A separate ghost investigation group, PROSE, returned to Patten Chapel in 2009. While there, members captured two EVPs. In one, a voice clearly says, "Here, now!" In the other, a voice whispers, "Michelle," the name of the investigator who had just spoken. The two young female investigators also reported being touched by an unseen entity on multiple occasions at this location. One had her hair pulled apart and her neck grazed. Given

Patten Chapel is thought to be haunted by multiple entities, one of which was witnessed running all around between these pews by PROSE members in 2008.

the gentleness of the touch, this was more likely the monk than our angry, swearing Indian. That same night, they heard footsteps and voices accompanied by a bright light (though no corporeal beings) in the hallway leading into Hooper Hall, as well as voices and piano music in Hooper Hall itself, despite the fact no one else was present. In addition, they captured several EVPs there, including one of a male voice clearly saying, "Time…it's time." They have preserved all of this evidence on their website.

We'll take our leave of the shades of UTC for now, although given the popularity of some, it is certain not to be the last time the living come looking for them.

THE HAUNTING OF THE HUNTER MUSEUM

JESSICA PENOT

The Hunter Museum is perched high above the Tennessee River. It sits above the city and looks down on the water below. It balances on top of an eighty-foot bluff and is filled with a long history. When you first walk up to the Hunter Museum, it seems like the last place in the world to be haunted. On a bright, sunny school day, children dance around the building. They come on field trips or with their parents for the numerous children's programs. They laugh and play and fill the air with the kind of bright-eyed joy that can only come from children at play.

The children aren't alone in their joy. Old couples holding hands and young students also fill the landscape around the museum. Before they go into the museum, they stop to look at the breathtaking panoramas that can be seen from the edge of the bluff on which the museum sits. They look at the lovely statues that grace the landscape outside of the museum. Once inside, they can explore art that ranges from the colonial period to the most contemporary. They'll see works by George Segal, Winslow Homer and Mary Cassatt. They will enjoy all of this beauty and never know that there is a darker side to the Hunter Museum.

The museum consists of three separate buildings with very distinct histories. The first two buildings of the Hunter are newer buildings that represent the unique beauty of modern architecture. It is the older building, known as the mansion, that houses the ghosts of the museum. The land beneath the museum is even older than the mansion. It used to be home to the Cherokee people. The Cherokees claimed that the high bluff was home

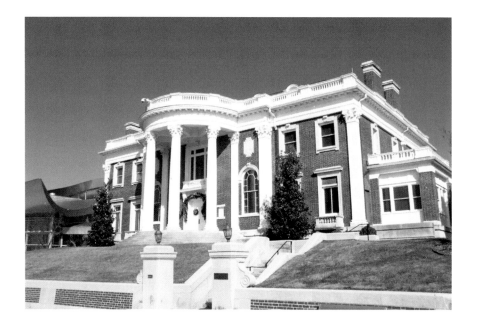

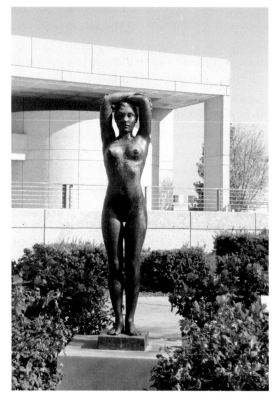

Above: The Hunter Museum.

Left: The Hunter Museum statue.

to a hawk god. The bluff was also used by both Union and Confederate forces during the Civil War as a lookout. From its first encounters with people, the ground beneath the Hunter Museum was important.

The mansion itself began construction in 1904. The home was commissioned by Ross Faxon, an insurance broker. In 1920, the home was purchased by Benjamin Thomas. Thomas was one of the founders of the Coca-Cola bottling company. His nephew, George Thomas Hunter, moved to Chattanooga to help his uncle in his work. George took over a prominent position in his uncle's business and, upon his passing, took over the mansion. Hunter was well known in Chattanooga for his philanthropic work and contributions to the city of Chattanooga. Upon his death, he gave the mansion to the Chattanooga Art Association to be used as a museum.

However, the ghost of Hunter Museum has nothing to do with this history. This well-known chronicle is only a piece of the haunted history of the Hunter. The main ghost of the museum originally haunted the old house that formerly stood next door, at 15 Bluff View. While the residents of 15 Bluff View were not as well known as the Coca-Cola family, they were nevertheless prominent in society. The ghost story of the Hunter Museum begins with a murder mystery.

In 1925, 15 Bluff View was known as Bluff View Home. The owner at the time found a complete skeleton buried in the floor of the home. She was mortified and immediately called the police to investigate. Investigator Joseph A. Paradiso was called in to probe one of the cases that would come to define his career. The basement was filled with evidence. The skeleton of a woman was clothed and the clothes were saved. Other items, such as jewelry and glasses, were found around the skeleton. The skeleton itself had a very odd smell that would be significant.

The bones were taken to the coroner. He found that the bones smelled of ammonia. The coroner would later testify that this was proof of murder. He said that bodies were treated with ammonia to mask the smell of decomposition and that whoever had placed the body in the floor was clearly trying to hide the body from discovery.

Neighbors were interviewed, and even the current owner had recollections of the people who had lived in the house. She remembered a family who resided there from 1913 until 1917. They had seemed like a pleasant family—a lovely couple named Mr. and Mrs. W.H. Bennett had lived in the house with their aged spinster aunt, Augusta Hoffman. Augusta was well liked, and the neighborhood children had taken to calling her Aunt

Gus. In 1915, neighbors recall that Aunt Gus just vanished. She went to the bank, took out all of her money and was never seen or heard from again. The Bennetts left the house shortly after and moved to Rome, Georgia. Before they left, the Bennetts told neighbors that Aunt Gus had moved to Washington to get married, but Joseph Paradiso thought that this scenario was a bit unlikely.

Paradiso didn't believe that an older woman who had spent her life as a spinster would suddenly vanish into the mist with a man no one who knew her had ever heard from. He also didn't think that she would take all of her money into a vague future that the Bennetts couldn't even specify. They could never name precisely where in Washington she had lived or gone. She had simply vanished.

Other evidence incriminated the Bennetts. The clothing that had been found on the skeleton had belonged to Augusta Hoffman, as did the jewelry and objects that had been found with the skeleton. The Bennetts were arrested, and the trial was a media sensation. I found newspapers articles from as far away as Pennsylvania that covered this horrible homicide. The bones were brought into the courtroom on a stretcher and laid out as testimony was given describing Ms. Hoffman and her nephew and niece-in-law. Until the very end, the Bennetts claimed that their aunt had fled in the arms of a secret beau, in search of love and marriage. Their testimony never wavered, but with a pile of bones laid out before them, their guilt seemed obvious. Who else would bury Mrs. Hoffman in the floor of their old home and take all of her money?

In 1925, the Bennetts were convicted for the murder of Aunt Gus. Although the conviction was later overturned, the evidence was clear. The couple had taken their aunt into their home, taken all of her money and buried her beneath the floorboards. They liked to live beyond their means, and Aunt Gus had the money to support their lifestyle. It is no surprise that Augusta Hoffman wandered the cliff-side mansion after her death. She was brutally murdered by those she trusted and loved the most and was left under the floor of the home that she loved.

In 1970, Bluff View Home was torn down to make way for a museum expansion. Shortly thereafter, employees of the Hunter Museum began noticing a woman wandering the halls of the mansion at night, admiring the artwork. The fear that a patron had somehow been trapped inside was quickly dispelled, however, when she faded away before their eyes, her bashed-in head becoming evident in the process.

Not many who work in the museum will talk about Augusta Hoffman's ghost anymore. Most know that there is some history of paranormal activity in the old mansion, but they don't know any specifics. A few of the older employees have talked about her. They say that her ghost can still be seen wandering the halls of the old house at night. She remains forever trapped in the neighborhood where she was betrayed and buried.

NEVER CHECKING OUT
OF THE CHATTANOOGA CHOO CHOO

AMY PETULLA

The Chattanooga Choo Choo hotel is home to thousands of visitors each year, who come to enjoy its comforts and revel in its history for a few days. Most folks don't know, however, that it is also home to more than one resident of a more permanent nature. You can even see a photo of one of them, still hanging on a wall there.

The railroad has been key to Chattanooga's history. It was a primary factor in the city's economic development, as well as a central part of its folklore, from the "Great Locomotive Chase" of Andrews' Raiders to the iconic Chattanooga Choo Choo, which became an eternal symbol for the city when Glen Miller's record of that name became the recipient of the first gold record in history. The railroad put Chattanooga on the map by making it the central connecting nexus between the South and North.

The Western & Atlantic Railroad Company dispatched the first train from Atlanta to Chattanooga on December 1, 1849. However, passengers were forced to depart the train in Tunnel Hill and take a wagon for the rest of the journey because there was no through passage. This was corrected by the construction of a tunnel in 1850. The actual phrase "Chattanooga Choo Choo" was coined on March 5, 1880, as a nickname for the Cincinnati Southern's first passenger train connecting Cincinnati and Chattanooga.

By 1904, Southern Railway had reached the conclusion that it needed a larger passenger terminal. In 1900, the prestigious Beaux Arts Institute in Paris, France, had held a contest for the best plans for a railroad station appropriate for a large city. Don Barber won the contest, and the president

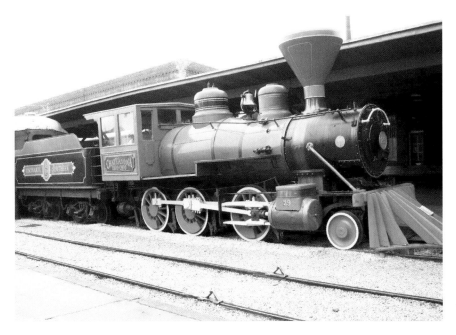

The Chattanooga Choo Choo, which sits directly in front of the model railway lobby containing the photo of the porter who continues to assist guests, even after his death.

of Southern Railway was so impressed with his plans that he invited Mr. Barber to a face-to-face meeting to discuss the new Chattanooga station. They reached an agreement to use Mr. Barber's award-winning plans for the exterior of the building and to incorporate the design of the chic National Park Bank of New York City into the interior design. The result was Chattanooga's Terminal Station. A bustling center in its day, the terminal saw fewer and fewer visitors as other methods of transportation surpassed railway travel, until the last train rolled into the station on August 11, 1970. Although the trains were gone, the Chattanooga Choo Choo was far from forgotten, as it was transformed into a hotel and vacation complex, currently owned by Historic Hotels of America.

In keeping with its beginnings as a major hub when the railway industry was in its heyday, the Choo Choo has a wonderful model railway museum on its premises. A wide variety of photos covers the walls of the lobby of that museum. In fact, you can find a photo there of Franklin and Eleanor Roosevelt, who stopped here on a train trip. Very close to that photo, you will see an old black-and-white picture of an African American porter standing by himself. His identity has been lost, although it is known that the photo

was taken in the 1960s. It is said that his ghost continues to attend to guests at the Chattanooga Choo Choo.

There are two versions of this particular legend. According to one, his insubstantial form is seen inside the hotel, often near the lobby area. Back in the days when railroad travel was a common and even luxurious method of transportation, and the Chattanooga Choo Choo was still a working railroad station, the current main lobby area, with its grand domed atrium, served as the Terminal Station entrance, through which all passengers coming and going would pass. In the hustle and bustle of a busy train station, with people scurrying to gather luggage, children and tickets and usher them onto and off trains before they left for their next destination, this area was where passengers were most likely to need assistance. So naturally, it is here where this ghost most often resides, seeking passengers who need his help, his unseen hand even moving luggage. Besides standard hotel rooms, the Choo Choo also offers accommodations in Victorian rail cars, and this entity has also been reported there, moving things. At least one guest photographed a smoky mist outside his rail car window after experiencing this spirit—the photo can be seen on Ghost Hunters of Asheville's blog.

The second tale of this particular ghost involves sightings of him outside, close to the railroad tracks. His personality is constant whether inside or out, as he endeavors to render whatever assistance is needed. In the case of the exterior sightings, he acts as a signalman, directing an unseen train long since departed. There is some documentation of this particular phantom, in addition to the photograph mentioned above. A local paranormal group did an "unauthorized" impromptu investigation of the Choo Choo Rose Garden in the wee hours of the morning during a local SciFi convention. They captured the sound of a man whistling as he went by, yet the film reveals that no living person passed near the camera. Many thanks to "JoeBob," who told me about the "whistler video," which can be seen on YouTube.

The other apparition attaching itself to the Choo Choo is a woman either with or in search of her child. Primarily she is reported in the lobby area, usually in the balcony under the dome, cradling her baby. She neither speaks nor appears aware of the living surrounding her but instead silently fades away after a few moments. Sometimes, however, she is searching for her child. Some years back, I was chatting with the women at the Sweetly Southern shop at the Choo Choo, telling them about the location's ghosts. While they claimed not to have heard of the haunting before, one of them looked quite

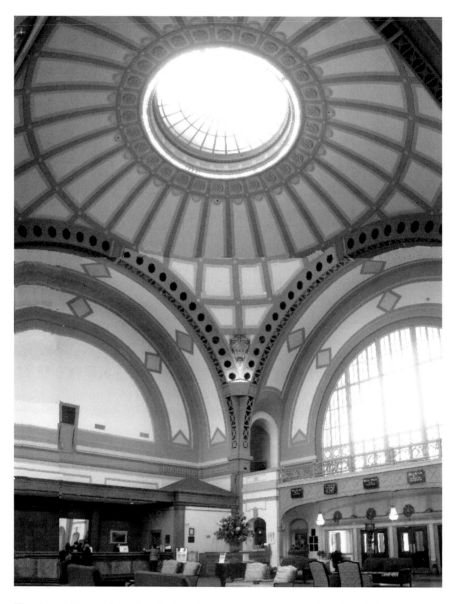

The Grand Dome of the Terminal Station entrance now graces the lobby of the Chattanooga Choo Choo hotel. The porter and the mother with, or in search of, her child are said to linger in this lobby.

startled when I mentioned the mother combing the station for her lost angel and relayed to me an encounter she had in that very shop before, which made sense in light of this legend. She had been in the shop alone one day when the door opened, and she sensed an unseen presence blow in and proceed to urgently go through the store, as if looking for something very important to her. Understanding lit her features, as she identified with a mother's frantic quest to locate her missing offspring.

A few years ago, I was puzzling about how these ghosts might have come to reside at the Choo Choo and created the following tale through conjecture that both wraiths were the result of the same incident. While there is no indication that a wreck of this nature ever occurred at this particular train station, it was entertaining to speculate about the possibilities. So sit back, relax and enjoy this mix of history and hypothesis.

On your next trip to Chattanooga, drop by the Chattanooga Choo Choo's Model Railroad lobby, and let your gaze linger on the portrait of a porter near the photograph of Franklin and Eleanor Roosevelt. Charles Anton came to work at Chattanooga's Terminal Station in the late 1950s. Up until he started there, Chattanooga had not treated him particularly well.

Chattanooga as a whole was better than most other southern cities to its African American citizens and their supporters from the North. In 1861, when the city voted to secede along with the state of Tennessee, Hamilton County elected to remain part of the Union. After the war, Chattanooga was one of the few southern cities that invited Union soldiers to remain as permanent residents. Even before the war, slavery was not widespread—only one in ten black men in Chattanooga was a slave, and only one in ten white men owned slaves. Later, in 1948, Chattanooga became the first southern city to have black police officers. However, "better than most" was a far cry from "fair."

Charles had lost his job as a cook at a local hotel when a white man—who had a fit when he found out that a black man had handled his food—falsely claimed to the management that he saw Charles spit in his drink. Later, when he tried to get work cleaning local businesses, he again encountered prejudice from the almost entirely white business owners and was unable to make a go of it. Finally, he got a job at a warehouse offloading freight, which he held for several months, until the warehouse burned down and everyone lost their job. He had gotten to know some of the folks at the railway while working at the warehouse, however, and they had all said that the folks at the

Chattanooga railway terminal did not care about the color of your skin as long as you took good care of the guests.

So he applied for a job as a porter at the terminal, and when he got it, he vowed to himself that he would be the *best* porter that depot had ever had, and it showed. Charles ensured that all of the guests arriving and departing when he was on duty got all of the attention they needed and then some. He not only carried the passengers' bags, he cared about the passengers themselves as well. If someone could not find their train or was unsure of the time, Charles was there to help. If a little girl got separated from her mother, Charles helped them find their way back to each other. He even helped out some of the other railway workers, becoming particular friends with the signalman out by the tracks. Especially on stormy nights, he made a point of pulling on a slicker and going out to take him a cup of coffee and check whether he needed a spare lantern. And it was on just such a wild, dark, stormy night when all of those factors combined in a supreme tragedy that left the Chattanooga terminal, and later the hotel that replaced it, with the spirits that haunt it to this day.

On that fateful night, Charles was nearly late for work because of the driving rain. The wind howled so fiercely that it threatened to blow his car off the road. When he finally arrived, he had barely gotten through the door when he heard a frightened, breathless woman cry out for help.

Meg Anderson had been widowed at the young age of twenty-three, leaving her alone in the world except for her infant daughter, Samantha. Fortunately, her husband had done well in business and had left them comfortably well off. Meg doted on her daughter, and she and Samantha were inseparable. By the time Sam was seven, Meg's features were evident in her, from her upturned nose to her freckles to her constant wide smile. They lived in Atlanta but traveled often by train to visit Meg's mother in Ohio. On this particular occasion, they were looking forward to the big Easter feast that they would have the day after they arrived.

Sam was especially excited, as she had gotten a tiny Maltese puppy as an early Easter present from her mother and was bringing him along in a small traveling basket to show off to her grandmother. The puppy, Jezebo, had been very good all the way from Atlanta to Chattanooga, giving only the occasional whimper but then quieting down when Sam stroked his head and whispered softly to him that the other passengers couldn't know he was there. However, when they got out in Chattanooga to stretch their legs in the Terminal Station, the storm in the sky was erupting like fireworks every few seconds, and poor Jez was nearly beside himself. He

pawed the inside of the basket so frantically that Sam lost her grip and dropped it, and Jez in his panic took off running through the crowd, with Samantha in hot pursuit.

Meg, who was burrowing in her purse for their tickets, did not initially notice what had happened, the noise of the thunder having overpowered the puppy's yelps and Sam's cries. She looked up just in time to see them disappearing into a huge crowd. With a terrified scream, she started running after them but had no idea where they had gone. She went only a few feet when Charles spotted her and grabbed her arm, saying softly, "Calm down, little lady, I'll help you find whatever you lost, just take a breath and let me know what it is." Sobbing now, Meg described her daughter and little Jez and how she had looked away for only a second, and then they were gone. They asked a few other passengers which way the little girl chasing her dog had gone, but they all pointed in different directions. They heard the door out toward the tracks slam but did not know if it was Sam or someone else who had gone out or even come in. Meg froze in an agony of indecision, afraid to go out and afraid to stay in, sure that whichever she picked would be wrong. Charles settled the issue for her, saying, "Missus, it is one ugly night outside. I'm used to looking in the dark at this here track. You keep looking here and I'll go out, and one of us is sure to find your little girl."

So while Meg continued to search the terminal and ask every passerby whether they had seen her baby, Charles grabbed his slicker and a spare signal lamp and headed out, following the tracks out toward his friend, the signalman. And over the keening wind, he often thought he heard the frightened cry of a young pup and imagined that he saw movement up ahead through the lashing rain. Chattanooga had not seen a storm like this in many a year, and while he ran as fast as he dared, he fell a few times in the mud, slowing him up. At last he was sure that it was indeed the girl and her dog up ahead, running right down the middle of the tracks, where it wasn't as muddy.

He breathed a sigh of relief as he saw they were slowing, sure that he could catch them before they went much farther, but his relief was short-lived. As he rounded a corner, he saw a bright light bearing down on them and knew that this one was not the lightning that kept illuminating the sky. It was a train! And Sam, still intent on her dog, clearly had not noticed it. The dog in his panic did not realize the danger that was approaching and perhaps instead thought it resembled the porch lights of home, a place of safety from the storm. Charles screamed out at them,

but his cry might as well have been a feather-soft sigh in the storm. He spotted his friend the signalman, who had clearly not seen the small girl, and it gave him an idea.

Just like the girl and her dog, he ran directly down the track, swinging his signal lantern as his friend had shown him, desperately trying to get the attention of the engineer to get him to throw the brake, praying that he would stop the train in time or that the child would jump clear of the tracks. When he was only several feet from Samantha, and the train was several yards away, close enough for Charles to see the engineer's features, the moment he had been praying for finally came. He saw horror cross the engineer's face as he reached for the brake, at last seeing the people he was almost upon. Charles realized at the last second that it might not have been soon enough, and in a herculean effort, he threw himself the last few feet to Samantha, intent on knocking her clear of the tracks. But he miscalculated his landing, instead striking his head on the rail, knocking him unconscious. Samantha, who had finally caught up with her pup, was pinned under Charles.

The engineer would later say that it was as if everything had suddenly switched to slow motion, as he watched in dumb horror while the slowing train plowed into the small pile of bodies on the track, devouring them even as he looked on. And at the very moment of impact, even though the train was not within sight nor sound of the passengers in the station, Samantha's mother Meg felt as if her heart had been ripped from her and sank to her knees with a heartrending wail.

It was small comfort to Meg and the engineer later to know that Sam had not suffered—that death had been instantaneous. They say that Meg lost her mind with grief. At Sam's funeral, Meg broke into fresh sobs every time she looked at the tiny coffin and wanted to climb into it with her daughter, so that she would not have to be alone and frightened. She knew what she had to do. After the funeral, she thanked all of her friends who came by to express their condolences and said all the right things—that it was God's will and that her daughter was in a better place. Then she quietly caught the train back to Chattanooga. In the wee hours of the morning, when all was quiet and nothing was stirring, she crept quietly into the Terminal Station, strung up a rope beneath the great dome that dominated the area and hanged herself, so that she could spend eternity with her precious Samantha. The true tragedy of the tale is that, as a suicide, she has been condemned instead to remain on this plane for the next century, in the place she committed her grievous crime. So while her precious Samantha slumbers peacefully in heaven, Meg mournfully roams

the lobby of the Choo Choo hotel, which now stands where the terminal previously served hundreds of passengers, still searching for her beloved child. More than one guest has seen the frantic woman, who disappears before their eyes beneath the great dome that still stands.

As for Charles, he got a grand funeral, attended by many of his friends from the railway and also by many passengers who read of his tragic death in the paper and remembered the man who had been so kind to them at the terminal. Yet Charles has not yet been allowed to go on to his rest, either. He blames himself for Sam's death, as he inadvertently trapped her when he attempted to knock her out of harm's way. And so he, too, continues to roam the hotel that now stands where the terminal once was, still seeking to help others—he occasionally even manages to move a guest's bag from the gift shop a few feet before the effort of carrying without a body becomes too much. Many a puzzled guest has wondered how the bag they were sure they set in one spot somehow managed to move a few feet away, unseen.

On stormy nights, Charles is also occasionally seen out near the tracks, frantically waving the signal light and still trying to avert the tragedy of that fateful night. One day, Charles's ghost will realize that the tragedy would have occurred with or without his tackle and that Sam was so focused on her puppy that she never noticed the train and would not have left the tracks. When that happens, Charles will finally get to go to his rest. But in the meantime, he continues to search for passengers in need of his help. Even if you are not one of the lucky ones who catches a glimpse of him scurrying through the hotel, you can still go by the lobby of the model trains and quietly pay your respects; here he still looks out of his photo to keep a watchful eye over the place he was happiest.

SOUTH PITTSBURGH HOSPITAL

JESSICA PENOT

South Pittsburgh Hospital is an out-of-the-way place. South Pittsburgh, Tennessee, is just outside of Chattanooga, hidden in the mountains. The hospital sits at the base of a lush, green mountain. The building has become a surreal place. It doesn't easily fit into any categories that most people have seen before. The hospital was once a respected community hospital. It wasn't enormous, but it served the small communities outside of Chattanooga. Since the hospital was closed in 1998, it has grown into something else. It has become something lost in shadow.

South Pittsburgh Hospital opened its doors to the community in 1959. The hospital was able to help the community in many ways. It had all of the usual units: medical, surgical, obstetric and intensive care. It also had a psychiatric unit and a geriatric unit. It was a busy and crowded little hospital. In 1997, another hospital was built in Jasper, Alabama. This hospital was newer and larger than South Pittsburgh Hospital and served many of the same rural communities as South Pittsburgh Hospital. The new hospital, Grandview, was also owned by Hospital Corporations of America and had been built to replace the older South Pittsburgh Hospital. South Pittsburgh Hospital soon closed its doors.

When you drive up to the hospital, the first thing you'll see is a small antique store. The antique store occupies the front of the hospital, and the entrance to the hospital is now lined with bubbling fountains and garden statues. The exterior of the hospital is deteriorating and decaying, but the fountains and the antique store bring it to life. They brighten the fading

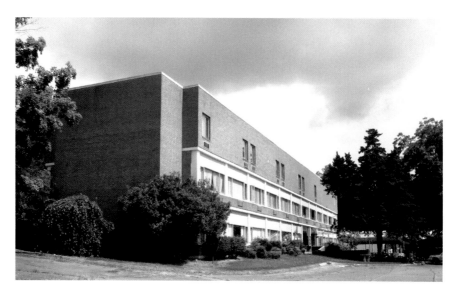

South Pittsburgh Hospital.

façade of the dead hospital and create a constant noise that surrounds the building, even in silence.

The antique store isn't the only thing that lives in the dead hospital. The inner courtyard of the hospital is filled with dogs that bark at those who wander inside the hospital. People live there as well. A family guards the hospital. They keep it open and tend to its needs. They live in several rooms on the first floor on the hospital. They keep the hospital open for paranormal investigators and groups that can pay to spend the night at the hospital and explore its haunted core. They form a private little group that seems surprisingly comfortable tucked away in the darkened heart of a notoriously haunted hospital.

Paranormal teams come to visit the hospital all the time. For a small fee, the grounds become theirs for a night. These paranormal teams are rarely disappointed. Evidence of a haunting is thick in the silent halls of South Pittsburgh Hospital. Many paranormal teams have spent the night there, and almost all come away with some evidence of the ongoing paranormal activity within. They leave with videos of moving objects and tapes of phantom voices calling out into the night.

The hospital is set up for these teams of paranormal explorers. When you enter, there is a sitting room designed specifically for these groups. There are several other rooms set up for haunted explorers, including an

The old waiting room.

The halls of South Pittsburgh Hospital.

old waiting room that has been decorated with antique medical equipment to set the atmosphere. Those rooms that are not set up are cluttered with an array of surreal objects that seem so out of place that you may forget where you are. There is a car in one hallway and old tires in the former emergency room. There are church pews in the basement and old furniture in the geriatric ward. Christmas decorations fill several rooms. Children's toys are scattered throughout the hot, empty halls. Added to this are the trigger objects that are laying in most of the halls. Trigger objects are objects that are laid out by paranormal teams and then videotaped for the night or however long the investigation persists. They are laid out and watched for movement. Their movement without cause is used as evidence for paranormal activity.

Southern Ghosts is one of the many teams that has investigated South Pittsburgh Hospital, and I was lucky enough to be invited to join the members on their adventure. We spent the night in the hospital with all of their equipment and amazing range of ghost hunting tools. Video cameras were placed in all of the hallways, and EVP sessions were conducted. EVP are voices that can't be heard by the naked ear but can be heard when taped and played back. In these sessions, the paranormal team asks questions of any ghosts that may be present in the room and then is silent for answers. On replay, the voices of the dead are said to answer back.

Southern Ghosts recorded many voice phenomena during its investigation of the hospital. One recording captured a female voice of unknown origin saying, "Old lady likes you." On the third floor, the psychiatric floor, an unknown female voice screamed while the investigators were questioning the ghosts. During another recording in one of the surgical rooms, an unknown male voice told the investigators to "get out" and then screamed at them. During another session, investigators were talking about where to go next, and a phantom voice can be heard on the recording saying, "Over here."

Southern Ghosts wasn't the only team to capture this kind of phenomena while exploring the hospital. Other teams have captured EVPs as well. Visitors and residents have also had many other kinds of ghostly experiences in the old hospital. One visitor to the hospital I interviewed said that he saw a man standing at the end of the hall in the psychiatric floor. It took him a few minutes to realize that the man he was seeing was a ghost. He seemed very solid and tangible until he vanished in front of him. Other visitors have had similar experiences in the old hospital. One visitor recalled seeing an old man sitting on one of the beds. Witnesses have described seeing trigger objects move across the hall.

The hospital still sits waiting for more teams of investigators. It will open its doors to any who are curious enough to pay to stay the night. The lodgings are not luxurious, but there are many who say that the ghosts are so thick at this infamously haunted hospital that you are almost promised at least one encounter with something paranormal.

THE GHOSTS OF LOOKOUT MOUNTAIN

JESSICA PENOT

It is impossible to fully explain the vastness of the history and beauty of Lookout Mountain in one small chapter. Lookout Mountain sits just to the south of Chattanooga and, at points, even dips its heels into Chattanooga, but the mountain is much larger than the city. Lookout Mountain stretches through three states and numerous small towns. It sits nestled in the corner of Georgia, Tennessee and Alabama. It is accompanied by numerous parks, waterfalls, hiking trails and rivers. Its cultural history is part of all three states, and its history is longer than the history of the United States. Even before the Romans took England, the native woodland people of the Americas occupied Lookout Mountain, lending it their folklore and legends. The first ghosts of Lookout Mountain were the ghosts of these people, and the first stories of the mountain were the stories of the Native Americans.

The first white people to come to Lookout Mountain fought the Cherokee Indians in 1782. There is some dispute as to what exactly, if anything, happened in this battle, but it is sure that after the white people came, there were many battles after. The first white residents of the area called the small Cherokee village they shared with the native people "Ross's Landing," after Chief John Ross, leader of the Cherokee nation, who maintained a trading post there. After the Cherokees were driven out, it became Chattanooga. From the very beginning, Lookout Mountain was important. It had all of the elements necessary to produce iron and was mined for these elements. In 1832, the Georgia land lottery allowed people to win parcels of land on top of the mountain, and people began to populate the area. Even with the

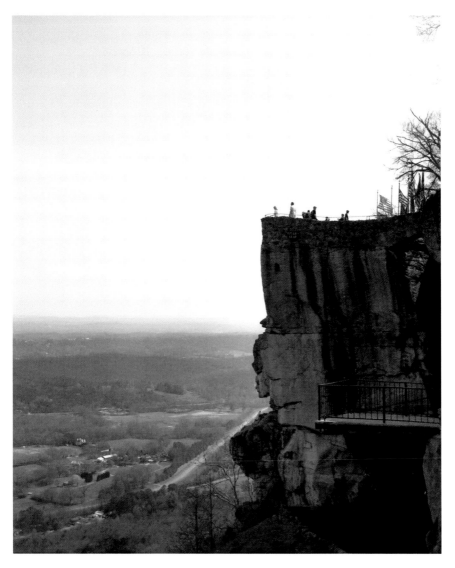

Lookout Mountain.

land lottery, the area remained mostly wild due to the difficult terrain on the mountain. Colonel James Whiteside owned much of the Tennessee side land on the mountain and built a turnpike to the crest of the mountain and to Summerside, a small town on top of the mountain.

The culture and history of the mountain was changed forever by the Civil War. At the end of his infamous Tullahoma campaign, General William

Rosecrans chased General Braxton Bragg just south of Chattanooga and engaged him. The series of battles that followed saw Rosecrans's men chasing Bragg's men through narrow mountain passes and into the mountains themselves. Bragg's men were able to take the mountain from Rosecrans and used it as a lookout position. When Rosecrans was replaced by Ulysses S. Grant, the tide of combat around the mountain changed radically. The Battle of Lookout Mountain was fought on November 24, 1863. Hand-to-hand combat took place on the slopes of Lookout Mountain in an area now commemorated as Point Park. The Battle of Lookout Mountain is often also called the Battle Above the Clouds because of the fog that hung in the air when the fighting began. Union forces took the mountain and kept it for the rest of the Civil War.

After the war, there was bedlam on the mountain. Bands of displaced Confederate soldiers still roamed the mountains until 1868. After a while, rumors of the beauty of the mountain began to spread, and bedlam was replaced by a steady stream of sightseers who came to sit atop the mountain. Seven states could be seen from atop this mountain, and its many caves and natural wonders became well known. It wasn't long before developers began to take advantage of this, and incline railways and famously lavish hotels were built atop the mountain.

Today, Lookout Mountain is the location of numerous tourist attractions. It is home to Rock City and Ruby Falls. It is home to Point Park, Cloudland Canyon, Little River Canyon, Desoto Falls, Noccalula Falls and Cherokee Rock Village. Tourists come from all over to see these many natural wonders. They come to chase white water in Little River Canyon, to climb in Cherokee Rock Village, to hike and camp and even hang-glide in Cloudland Canyon and, sometimes, to see the multitude of ghosts that creep out of the stone of the old mountain like a steady stream.

One of my favorite ghosts of the mountain is also one of the oldest. This story comes from the Alabama side of the mountain and is the story of the ghost of Noccalula Falls. The ghost that haunts these falls is said to be the ghost of an Indian princess. This princess fell in love with a brave from her tribe. The princess was meant for another, however. Her father forbade the union of the young lovers, and the Princess Noccalula was crestfallen. Her heart broke, and she wandered up to the top of the waterfall in utter desolation. The beautiful maiden threw herself from the top of these treacherous falls and fell to her death. When her father learned of what happened, he was also heartbroken and named the beautiful waterfall after his beloved daughter. To this day, many people describe seeing the ghost of

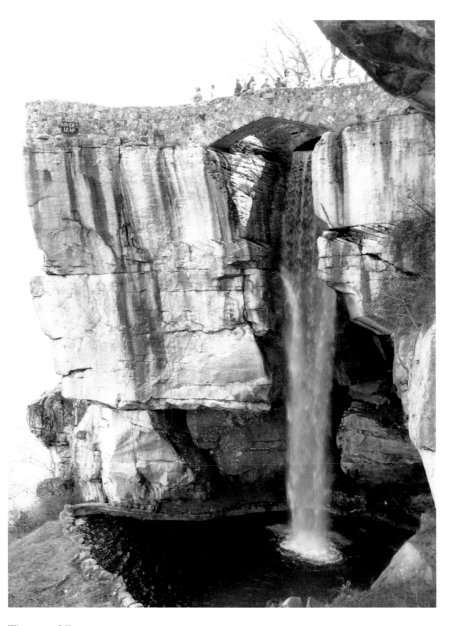

The waterfall.

the lovely Noccalula wandering the tops of the waterfall, forever mourning her lost love.

It is not surprising that the Civil War left its fair share of ghosts behind on the mountain. So many men died that their sorrow has left an imprint in the stone. One of the more famous ghost stories of the mountain is a about a group of Union soldiers that got lost while fighting in the skirmishes at the base of the mountain. They became so lost that they wandered away from the battle to the other side of the mountain. They had already seen combat, so as they wandered the mountain they lost blood, food and morale. This was only made worse when members of their group began to die. Unfriendly locals helped pick off the gang of lost men, driving them deeper into the woods and further into a state of panicked madness as they realized that they might not ever make it off the mountain alive. The last that was seen of this lost regiment, there were only seven Union soldiers left alive. They were last seen in Blanche, Alabama, heading up the mountain. Residents of the area still say that they see the ghosts of the regiment, however. They say that they hear the soldiers' ghosts crying out in the night. They say that the ghosts of the lost regiment still wander the mountain, trying to find their way home.

One of the most famous attractions on Lookout Mountain is Ruby Falls. More than 400,000 people per year visit this wonder, which is called one of the highest underground waterfalls in the country. According to local legend, one of the early explorers of the caves associated with Ruby Falls was a man named Lomax. Lomax was mapping the cave system and managed to creep his way deeply into the system when his light failed. Without light, Lomax was lost. A search party was sent in after Lomax. When he was found, every hair on his head had turned white, and he was too terrified to speak of what had happened to him in the caves. Lomax left the area, never to return, but when further exploration of the cave was completed, old bones were found in that cavern. They say that the icy fingers from the ghosts of those who left their bones behind had gripped Lomax in the dark and driven him mad with terror. They also say that so many similar events happened in this mysterious room that it was walled off and never used again.

There are also stories of haunted houses and more classic hauntings lurking in the shadows of Lookout Mountain. There is a community on Lookout Mountain called Fairyland. The center of this community is a gorgeous Tudor Revival–style building that is called the Fairyland Club, said to be haunted by a ghost named Bobby, which roams the building torturing the guests and causing general chaos. He is said to be the ghost of a man

who lost his love to another, so he is particularly hard on the ladies. Women often report feeling him breathing down their necks or following them into the bathrooms.

There are many more ghosts here. The fog can hang thick on Lookout Mountain, but the ghost stories are thicker. They are so thick that one local folklorist wrote an entire book dedicated to all of the things that lurk in the shadows of the old stone of this mountain. Larry Hillhouse collected many of the stories I've written about here, as well as others. There are stories so dark on Lookout Mountain that they make the caves seem bright, and they are so numerous that if you wander around the mountain, you are bound to trip over one eventually.

HANGING WITH HEROES AND HOOLIGANS

AMY PETULLA

J ails, as places that generate strong or violent emotions, often have residual paranormal activity—not ghosts per se, but echoes of a sort that have attached themselves to the location where they occurred. These can occur even in the absence of any death. If the occupant of a jail died, however, particularly if they were executed, it is more likely that it would be their actual spirit, rather than just residual energy, that remained behind.

Downtown Chattanooga had not one but two jails that detained inmates who were later executed. The old Hamilton County jail is memorialized by a monument that stands in front of the Justice Center, at the location of the present Hamilton County jail. Swaim's (or Swim's) jail was located at the corner of Fifth and present-day Lookout Street. Just as with the old Hamilton County jail building, it was torn down decades ago, but some people believe that inmates of both are trapped there still, just as they were during their lifetime.

Officers merely had to escort the condemned men of the old Hamilton County jail downstairs to reach their deadly destination. A tiny, dimly lit room in the basement under the jail's office was entirely consumed by the structure that haunted their nightmares and filled their days with dread: the gallows. The grim tasks carried out there could be viewed from the hallway through a small grate in the wall.

According to a 1904 newspaper article, Buddie Wooten and George Knapp robbed a saloon on Rossville Avenue in 1895, bashing in the sleeping saloon keeper's head in the process. Wooten and Knapp were arrested, tried,

found guilty and sentenced to hang. Buddie and George plunged to their death together, but Wooten, described as the worst of the two, was the one who fought the most to hang on to life, the one last to die.

After Wooten and Knapp were gone, the gallows remained silent and still for nine years, rotting away. It was not, however, left wholly alone. Over the years, occasionally prisoners or guards reported seeing a thin, gray shape looking out the grate from the execution room into the hallway, standing on the scaffold itself or dangling in the dark under the trapdoor. This sight was inevitably followed by moans, groans and the sounds of a person being strangled to death—then the shape disappeared. It was rumored that the shape was Buddie, allowed a temporary reprieve from the overly hot climate of his present abode in order to visit the scene of his last moments on earth and reenact his death. The rumor among the prisoners was that the last inmate to die on a gallows was allowed to return to visit it until the next man was executed.

While reenacting one's death does not hold much appeal for the living, apparently it is literally a breath of fresh air for the dead condemned to the nether regions, one that Buddie Wooten regularly accessed. His appearances even occasionally aided his old enemies, the guards. When an inmate was loath to return from his daytime accommodations in a locked corridor to his cell, the guards would turn the water hoses on him, and if that did not work, he was locked in one of two pitch-black dungeons, which generally subdued the problem prisoner within a matter of hours.

One particularly recalcitrant prisoner, Piggie Jones, was still full of spit and vinegar after both "treatments" were attempted. Piggie screamed. He pounded the walls. Even after being chained and left in the lightless hole all night, Piggie continued like a two-year-old in the deepest throes of a temper tantrum, screaming, "Nooo!" when asked whether he would now obey. However, as the jailer was leaving, the cell suddenly became as quiet as a tomb. The silence was broken by a sudden screech from Piggie, promising frantically to behave if only they would remove him from the dungeon. Presumably, Buddie had put the fear of God (or the devil) into this little Piggie, something neither the stygian blackness of the dungeon nor the pounding of the icy water in the glacial lockup could accomplish.

Buddie's visits remained fairly peaceable until nine years after his death, when convicted murderer Alex Armour was condemned to hang by the neck until dead on the very scaffold last occupied by Buddie. Incensed at the upcoming usurpation of his only earthly refuge, Buddie became quite agitated and active. He quieted down when Alex's case was appealed, only to

resume his activities as the date approached for the decision on the appeal. At the time that the 1904 article was written, that decision had not yet been rendered, and the jail was rife with speculation about the lengths to which Buddie would go to protect his domain if the appeal was denied.

The jail has been rebuilt and the gallows long since retired, so Buddie no longer has the opportunity to haunt the same room. However, reportedly people continue to get ghost photos outside the current Hamilton County jail, which sits at the same location as its predecessor. I myself got a photo of a large orb there on a recent nighttime stroll through the city. Whether it was the reflection of an animated speck of pollen dancing on a breath of air or the animated remains of Buddie, briefly escaping his confines for a quick breath of his own, is a matter best left to opinion and conjecture.

Just a short walk from the Hamilton County jail, you will find at the corner of Lookout and Fifth Streets a marker memorializing the former location of Swaim's jail, home for a time to the famous Andrews' Raiders, about whom Disney made the movie *The Great Locomotive Chase*. Originally, Swaim's was a jail for runaway slaves, but when the Civil War exploded on Chattanooga, the jail was temporarily turned into a brig for captured Union soldiers. By all accounts, the prison was a hellhole. Run by a brute of a man for whom the jail was named, Swaim's contained a dungeon beneath a trapdoor in the floor, where prisoners were locked into a nightmarish, pitch-black, rat-infested thirteen- by thirteen-foot abyss, sweltering hot and putrid with the stench of human waste wafting from the open buckets that were the inmates' only toilets. It was this pit to which the Raiders were damned after their capture.

James Andrews was a civilian who had concocted a grand scheme to defeat the Confederacy. Recognizing the large part the railroads played in keeping Confederate armies fed and supplied with weapons, goods and information, Andrews planned to hijack a Western & Atlantic train and travel the tracks, burning bridges and raining destruction on the rails in his wake. He secured the assistance of several Union military men, as well as at least one other civilian, and began making plans.

Disguised as Southern sympathizers, they began scouting the area on April 10, 1862, and on April 11 boarded a train for Marietta, where they planned to initiate the theft. The next day, when word came that Huntsville, Alabama, had fallen to General Ormsby Mitchel, the Raiders put their plan into action. They hijacked the General from Kennesaw, Georgia, while its conductor, W.A. Fuller, was having breakfast in the station. Furious, Fuller took off after the train on foot and, after two and a half miles, switched to a

polecar. Although he and his men fell behind due to the havoc Andrews was wreaking on the tracks, they transferred to the Yonah locomotive, and the tide turned when the Raiders were held up by a crossing train. Fuller and his men switched again to the Texas, which rapidly caught up.

Six hours after the theft, the Raiders abandoned the General when it ran out of fuel just before reaching Chattanooga and scattered in the woods. A search with bloodhounds led to the separate captures of William Campbell, Jacob Parrott, William Pittinger, James Andrews and a few other Raiders within a few days, and when questioning (and in the case of eighteen-year-old Parrott, hundreds of lashes) was unsuccessful, it was ordered they be taken to "the hole." The remaining Raiders were quickly gathered up, as the Rebels realized from the excuses of the first few that any man claiming to be from Flemingsburg, Kentucky, and desirous of joining the Rebel army was, in fact, one of the trainjackers.

The number of men in the tiny cell swelled to twenty-two. The crowding was so severe that, according to William Pittinger, when one man turned, everyone in his row had to turn also. The fetid odor of the buckets was compounded by the stink of unwashed bodies and the tainted smell of fear. Although handcuffed and shackled together, the Raiders learned to free themselves of their cuffs. After receiving news on May 31 that Andrews had been condemned to death, they decided to attempt escape within the next two days. During the course of the escape, Andrews accidentally hit a loose brick with his foot, alerting the guards. Only he and one other prisoner, John Wollam, escaped; the others returned to their cells and put their chains back on. Andrews was recaptured two days later, Wollam a few days after that.

To prevent future escape attempts, James Andrews's legs were welded into heavy fetters. He was taken to Atlanta for execution, and on the way to the scaffold on June 7, his guards made sure to march him past the hole where his body would be buried. When he was hanged, they refused to remove the fetters, and the weight stretched the rope to the point that his feet touched the ground. Rather than rehanging him with a shorter rope and knot properly adjusted to snap his neck, the guards simply dug the dirt from under his feet and allowed him to slowly strangle to death while dangling there. His body was tossed into the hole without a coffin. Seven of his companions were hanged on June 18. William Campbell and Samuel Slavens broke their ropes and were hanged a second time, and all were buried together in a trench. Later, the bodies of Andrews and the other seven were reinterred at the National Cemetery on Bailey Avenue in Chattanooga. A train replica monument, donated in 1890 by the State of Ohio, prominently marks

A replica of the General locomotive memorializes Andrews' Raiders. The seven executed men are buried in a semicircle behind the monument. James Andrews's grave can be seen to the left of the monument in this photo. One fanciful legend reports that this train leaves its monument at the full moon to traverse the cemetery's gentle slopes.

their graves near the cemetery's entrance. Nineteen of Andrews' Raiders, including four of the men hanged, were awarded by Congress the very first Medals of Honor, although Andrews himself along with Campbell, as civilians, were ineligible for the honor.

There are two ghost stories associated with Andrews' Raiders. One is told at the site of the old Swaim's jail by a tour group in Chattanooga. According to the guides, two shadows are seen darting around the area of the old jail that are thought to be the ghosts of Andrews and Campbell. Certainly, given the circumstances of their final days, the trauma of both their deaths and the lack of Congressional commendation for them, they are among the most likely of the Raiders to continue to anguish beyond the grave. Disembodied footsteps and ghost photos have been reported at this location. When I attempted to take a photo of the location during the day, I jumped and nearly dropped my camera when the screen revealed a tall green figure looming in front of me. Seeing nothing with the naked

eye, I moved a couple of times, yet the onscreen figure still loomed. When I finally snapped some photos, a sunburst appeared on each photo where the green form had been. Apparently, glare was the cause of the anomaly. In the daytime, this explanation makes perfect sense. At nighttime, however, this street is deserted and silent, and imagination enjoys free rein to create footsteps from what are surely just animal rustlings…right? When I walk past that location now, I still give it a healthy berth just in case.

The other story associated with James Andrews and his courageous gang is much more entertaining and fanciful. According to this legend, during the full moon the train replica actually leaves its monument and traverses the many hills of the large and flowing cemetery in a small-scale re-creation of the actual General's famous ride. The pedestal is left empty, and a soft moaning, like the chuffing of a train running at full speed, can be detected echoing among the trees. Lest you scoff, let me point out that this is far from the only report of a ghost train. Such phenomena abound, from the legendary funeral train of Abraham Lincoln that is said to appear each year on the anniversary of its passage to the whistle of a train long gone, described herein at Hales Bar, to the reputed annual phantom re-creation of a horrific 1891 locomotive wreck in North Carolina's Iredell County, which in August 2010 caused the death of a ghost hunter on the tracks at the wrong time in search of the apparition. Should you encounter such an engine some night at the National Cemetery, you'd be wise to show some respect and stay well back—this train is in a big hurry and not inclined to make stops for southerners.

RACCOON MOUNTAIN'S GUARDIAN
OF THE CAVERN

AMY PETULLA

Many people are aware that the Southeast's most well-advertised cave, Ruby Falls, is located in Chattanooga. However, not as many are familiar with a jewel of a cavern nestled at Chattanooga's westernmost exit. And even fewer know about the cave's permanent guardian.

Although not as well known as its famous cousin, Raccoon Mountain Caverns is, in fact, rated the number one cave in the Southeast and one of the top ten caves in the entire United States. At least one website reports a section of the cave to be the most challenging cave tour in the country. Both Raccoon Mountain Caverns and Ruby Falls were discovered by Leo Lambert. Mr. Lambert, a chemist and cave enthusiast, was distressed when the natural entrance to Lookout Mountain Cave, on the banks of the Tennessee River, was shut off to the public when the Southern Railroad Company constructed a tunnel through some portions of the mountain in 1905. He developed an ambitious plan to drill an elevator shaft from higher up on the mountain hundreds of feet down to the cavern. The excavation began in 1928, and in December of that year, the cave currently known as Ruby Falls (named after Lambert's wife) was discovered. The following year, he was invited to explore the source of air blowing through limestone rocks located on a portion of Raccoon Mountain known as "Mount Aetna," owned by the Grand Hotel and used as a farm for its restaurant. Farmers there used the rocks for natural air conditioning on hot days. Mr. Lambert expanded the cracks and discovered an extensive cave passage. He widened the passage, created

trails and opened the cave as a tourist attraction, featuring the beautiful Crystal Palace Room, in 1931.

Raccoon Mountain Caverns contains more than five and a half miles of passages and is still being excavated. The cave was originally known as "Tennessee Caverns," later as "Crystal City Caves," and was given its current name in the 1970s. The caverns offer a forty-five-minute Crystal Palace Tour, which also includes visits to the wishing pool, the reflection pool (caused by the presence of manganese in the water), Iguana Rock, the Hall of Dreams, the Cave Shield and the Snake Pit (which does not, despite its name, contain any snakes). The Cave Shield, a rare feature hanging down from the top, without the sides touching the rest of the cave, is made even rarer by the appearance on the front of the shield of an image like a coat of arms. Only a handful of such cave shields exist, and this one is a large factor in Raccoon Mountain's high rating. Besides the tour, Raccoon Mountain Caverns also offers several Wild Cave and overnight tours that take intrepid travelers deeper into the cave. The Crystal Palace Tour passes the three entrances to the Wild Cave sections.

Raccoon Mountain is located on Highway 41, a short way from the I-24 Lookout Valley exit. The Trail of Tears Cherokee evacuation route passes the mountain, quite near the cave. It is unknown whether the cave was used by the Cherokees here either during or before the evacuation, but given the nearby freshwater source, it would not be surprising. The property was purchased sometime in the 1960s by Harrell Boyd and later by the Grahams. It was acquired by the present owners, the Perlaky family, in 1995. Currently, besides the caverns, Raccoon Mountain also has a gift shop, a campground, cabins and go-karts. However, it has previously been home to additional amusements. In September 1964, the sky ride was opened. Later, in 1979, Raccoon Mountain Recreation Park was added, which included a waterslide, an alpine slide, go-karts, a hang-gliding simulator (later moved) and horseback riding. The recreation park was closed in 1999 with the development of Cummings Cove subdivision and the Black Creek Golf Course. The go-karts and gift shop, however, were retained, along with the caverns.

During the 1960s, the caverns administrators retained the services of a night watchman to keep an eye on the property during late hours. Willie Cowan, a middle-aged gentleman who also served as a maintenance man, is said to have been friendly and well liked. He loved the caverns and was reported to be partial to flannel shirts. Willie made regular rounds of the gift shop and caverns after dark to ensure the safety of the place. At the

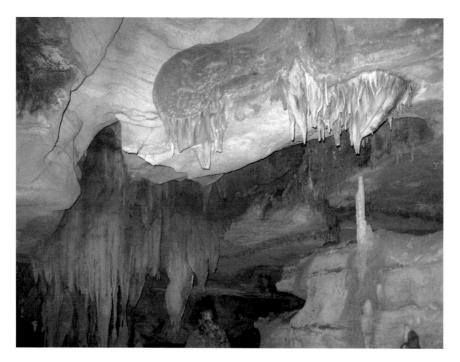

Raccoon Mountain's Cave Shield is a rare and lovely feature that contributes to its rating as one of the top ten caves in the country. It is also one of the locations where orbs are seen.

conclusion of each circuit, he would return to a small room, where he would sit, waiting for his next round. He had a penchant for smoking cigars or pipes in between rounds. On the night of November 30, 1966, Willie was on duty and fell asleep smoking in the gift shop. The cigar fell and caught the shop on fire in the early morning hours of December 1. The fire spread throughout the gift shop to the main building and eventually to the power plant for the sky ride, all of which were destroyed. The headlines read, "Watchman Found Dead in Ruins of Highway 41 Tourist Attraction."

Sometime thereafter, employees began reporting odd occurrences. The smell of tobacco smoke was reported dozens of times in the caverns. Visitors or guides occasionally reported seeing what appeared to be a person in the cave passages who subsequently vanished. Odd sounds, including whistling, were heard. A carving in the cave wall that originally read "Dead End" mysteriously changed to "Dead Man."

When the Perlakys took over the property, they became gradually intrigued with the reports of a possible ghost. Patti Perlaky began keeping a log of odd

occurrences. As the story became more acceptable to discuss, the guides grew less reticent to talk about what they had experienced.

Both the Perlaky family and the cavern guides were very gracious and welcoming in discussing their permanent visitor with me. Erin Hines, one of the guides, reported a number of encounters with the entity that they all call "Willie." She reported smelling the cigar or pipe smoke on a number of occasions. She says that she usually detects the odor between the speleothem known as "Iguana Head," because of its resemblance to a head, and the Hall of Dreams. She heard whistling on one of the first tours she conducted, in 2007. When she looked toward the sound, she actually saw Willie near Headache Rock, close to the entrance to the cave. When it registered with her what she was seeing, she took a step toward him, and he went behind the rock and disappeared—the whistling then stopped. She described him as an older man in "ratty" clothes, with a long beard. On another occasion that year, while conducting a lantern tour, she saw orbs with her naked eye. While many people have had orbs show up in photos in the cave, most often in the Hall of Dreams and sometimes at the cave shield, it is much rarer to see them in front of you like that. When we visited, I did not see anything like that on my camera screen as I snapped photos. However, when I put them up later on the computer screen, sure enough, there were several photos with orbs in them in various locations. While dust, rain and solar flares are frequent causes of orbs, because of the nature of a cave, those explanations would not suffice there. Perhaps they were reflections of some sort. Then again, who knows?

In winter, the air flow will suck the door between the cave and the gift shop in, and in summer it will slam shut. In fall and spring, however, there is no air flow in the cave. Nevertheless, during one fall day, while in the gift shop, Erin heard the sign clatter against the door, as if someone was rattling the door. She called out, "Willie, stop it." When she said that, the door mysteriously opened.

Another guide reported hearing a group of people talking at the rope climb portion of the Wild Tour. At the time, he assumed that another group was in the cave. Upon checking after exiting the cave, however, it was discovered that there was no one else in the cave at the time. At another time, he was in the cave with just one other person, who was right there with him. An unseen entity threw rocks at them. Upon checking, they discovered that, again, there was no one else in the cave besides them.

Until the late '90s, one of the owners, Bob Perlaky, was not even aware of the existence of a ghost at the cave. He was presented with proof that

was hard to refute, however, when on his first encounter, he actually saw Willie when taking a group through the cave. While near the second Wild Cave entrance, he saw the figure of a man in a red flannel shirt about fifty feet away, moving back and forth and back again. At the time, he assumed that someone had snuck in, and after instructing the group to remain where they were, he gave chase. The figure disappeared. Bob ran all the way back to the entrance but found no one, nor did he hear the door out of the cave open or shut. He did, however, smell smoke on the way back to his group. He later described the encounter to his sister Patti, who proceeded to fill him in about the ghost.

Guides and guests continue to frequently report smelling cigar or pipe smoke. This happens most often around the end of November or in December, near the anniversary of Willie's death, and usually near the reflection pool or between Wild Tour entrances numbers one and three. At this point, tour groups are 130 feet below ground, far from anyone who might be smoking on the mountain. About a year after seeing Willie, Bob encountered even more definitive proof of Willie's fondness for tobacco.

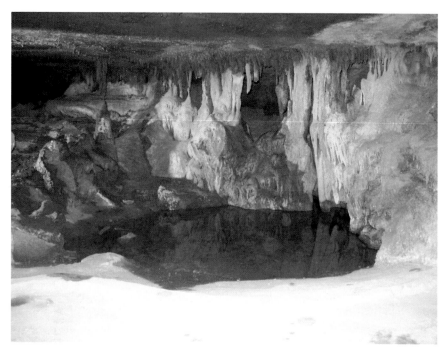

People often smell Willie's tobacco smoke near the reflection pool, particularly near the anniversary of his death.

He had been right outside the cave talking with some other folks when he heard the cave door slam. The door had already been shut, and no one came out, so they went to explore the sound, as no one was supposed to be in the cave at the time. Under the door, they could see that the light, which was controlled by a motion sensor, was on in the ladies' bathroom, but no one was in there. Bob ran one way, and the others ran in the opposite direction, meeting right around the Wild Tour entrances. Neither Bob nor the others had encountered anyone, and no one unfamiliar with the cave could have run through to the Wild Cave entrances in that amount of time and missed them. Nevertheless, where they met, they saw a little steam rising from a small quantity of tobacco spit there on the ground, which none of them had left.

Besides the smoke smell, many guides have described the distinctive smell of carbide in the caverns. Back in Willie's day, people used carbide head lanterns when exploring the caverns, where a pack of water worn on the hip connected through tubing with the headlamp, which contained calcium carbide; the chemical reaction between the calcium carbide and water produced acetylene gas, which ignited a soft light. Carbide lamps were so prevalent that they came to be the symbol of caving, but they gradually gave way to the use of electric lighting in caves. In 1984, manufacture and distribution of such lamps ceased in the United States. While production resumed here in 2002, they have not been used in Raccoon Mountain Caverns in decades. Nevertheless, Willie apparently prefers the equipment in use at the time of his death.

Patti Perlaky, who served as manager for the place, lived upstairs from the gift shop for a time. She would hear lots of noise, like a party going on, when no one else was present. The sound of someone walking on the steps and across the room often reached her ears. When she checked, no one was there, but half an hour later, Patti would hear Willie on his rounds again.

Patti tells an interesting story about the time she saw the ghost. She was spending the night in the cave and had her sleeping bag pulled up over her face to stay warm. When she peeked out from under it, there was a blue light hovering near her head, right outside her sleeping bag. She sat up, and the light hovered about two feet above the ground for a short time before heading down a crawl space, back to the walking path and disappearing.

The Perlakys and other folks at Raccoon Mountain graciously took me along with them on a hunt for Willie recently. Their various ghost-hunting technological devices did produce some very interesting results, but as with any technology in this field, there are always doubters. I happen to be

one of them, although it was impressive. What was even more interesting was what I saw with my own eyes. Despite my involvement with this book and the ghost tour, supernatural experiences just don't happen to me. So when I saw a faint blue light shining on one of my companions in a cave with all the lights off, two hundred feet below ground, where no light could filter, I simply assumed that someone had turned on their flashlight and covered it with their hand so that it was barely shining. Yet when I asked who had their light on, I was greeted initially with silence, followed by, "What are you talking about?" No one else saw the light. Perhaps my eyes were just playing tricks on me. But a few moments later, when the light I could still see brightened, moved right behind Kristen's left shoulder and began flashing, everyone else started exclaiming, as they saw it, too—everyone but Kristen. Suddenly, she cried out and said that she had just felt something poke her left shoulder. We had not mentioned where on her the light was shining. Perhaps other skeptics out there will explain the lights away as being from the equipment (although it was the wrong color and in the wrong spot) or some strange floating cave gas, and the poke as being a figment of the imagination, with a lucky guess as to location. As for me, logical explanations become increasingly tenuous as the number of unlikely factors involved increase.

When we took a tour at Raccoon Mountain, there *was* a sweet smell in the cave, although the odor was closer to perfume than cigar. Our guide, Kelly, shared with us his experiences with Willie, because we asked. The guides at Raccoon Mountain are very informative about the cave's geology and history. However, while they all seem to also be knowledgeable about the cavern's permanent resident, the folks there generally do not include the ghost information on the tour, for fear of spooking guests, unless they are specifically asked about him. They are continuing to experiment with their equipment, however, so if you are lucky enough to visit this beautiful cave, do inquire after Willie. He seems to be continuing his efforts to look after "his" guests.

Eternal Denizens of the Valley

AMY PETULLA

While ghosts abound in Lookout Mountain, its hauntings are also spread to the sleepy hamlets at its foot. From hidden graveyards to venerable old homes to a historic tavern, the spirits of St. Elmo and Lookout Valley still tarry in this town.

St. Elmo, at the foot of Lookout Mountain, is one of those old areas that is renovating its way toward funky and artistic. It has not, however, left its past behind, and historic cemeteries, churches and old houses both lovely and decrepit can be found less than a mile from the small downtown area. Incorporated in 1905, this community was founded in 1866 by Colonel A.M. Johnson, who bestowed the name in honor of the book of the same name and year by Augusta Evans, who had set the opening scene of her book in the neighborhood. Mrs. Evans had spent several seasons on Lookout Mountain, and Colonel Johnson, in an essay on the area written in 1896, speculated that she felt the view from there resembled the picturesque outlook from St. Elmo Castle in Naples, Italy. He described the history of the portion of St. Elmo adjoining his homestead as "anything but savory," filled with saloons, gamblers, horse racing, cockfights and shooting games.

The townspeople set about correcting that, and its ordinances at the time—in addition to prohibiting the usual activities such as gambling, prostitution and the like—also forbade women from walking the streets after 9:00 p.m. and likewise prohibited men from walking or riding with any "woman of the town or prostitute" on the streets at any time of the day or night. Perhaps to ensure that this rule was not skirted, they also prohibited

wearing the clothing of the opposite sex in public. To cover all of their bases, they proscribed flying kites, throwing missiles and using slingshots on the streets and also specified that skinny-dipping was only allowed in areas not within sight of streets or occupied homes or businesses.

Every community needs a domicile for its deceased, and though many don't know it, St. Elmo in fact has two. Established in 1880, Forest Hills Cemetery cradles many of Chattanooga's most well-known natives in their eternal rest. Some are not happy to be there. William R. Frye's epitaph sums up his feelings: "I came here without being consulted and leave without my consent." Most people in town are familiar with this lovely, sprawling necropolis. Very few, however, have laid eyes on the much smaller Thurman Cemetery, dedicated as such in 1873 by early St. Elmo settler Elijah Thurman, who was buried there that year. This forgotten plot, tucked away in the woods near the Orange Grove Residential Refuse Collection Center, is the quintessential graveyard, with its dark shadows, vegetation eager to grasp the unwary passerby and overall eerie aura. While lists exist that purport to set out the identity of all of the bodies buried there, these accounts do not contain the names of the corpses that lie beneath several square-shaped unmarked stones, clearly also intended as grave markers. This cemetery was first described to me as a slave cemetery, and perhaps that is the explanation for the marked difference in the two distinct types of tombstones.

According to the folks at PROSE, both cemeteries are haunted. Forest Hills is reportedly home to the classic weeping woman who disappears in a flash of white. PROSE member Victoria saw her twice. There is also a large black shadow form that prefers strolling through the grounds. Forest Hills backs up to the Bi-Lo grocery store. Victoria and Jeremy saw this particular shadow creeping from the back of Bi-Lo one night, returning to his dank grave in the bone yard.

The spectral couple are not alone in this city of the dead. In the back portion of Forest Hills is a children's cemetery. The unearthly cries of the infants echo among the gentle slopes. One young lady confirmed hearing the heartrending wails when we spoke. In addition, some of the living have worried at seeing children wandering among the headstones, only to have their concern turn to shock at the youngsters' sudden disappearance.

As to the Thurman graveyard, the legend relates that if you visit late at night, you will see slaves there, mourning their lost lives, both what was and what should have been. At least one other apparition is also believed to linger, on occasion, at this location.

Thurman Cemetery contains two very distinct types of graves, intermingled among each other. The more traditional graves of the Thurman family can be seen in the back and far right of this photo. The small, uncarved square stones seen in the foreground are thought by some to be markers for slave graves.

PROSE conducted an investigation of one of the historic homes in the area, located near the site where Colonel Johnson's house had burned down years earlier. One of the three phantoms in that house is an old uniformed soldier. One evening, a friend who was sensitive toward ghosts saw this soldier float from the home, apparently highly agitated, but rather than turning right toward Forest Hills, the ghost turned left. At the time, one of the skeptics among PROSE believed that he had caught the "sensitive" in trickery, thinking that the man had been confused about the location of the cemetery and tripped in his story. Neither the psychic nor the skeptic (nor anyone else present save one) was aware of the Thurman graveyard, which at night is nearly imperceptible in the woods, yet that was the area toward which the specter was heading. Was the ghost a member of the Thurman family returning home? Or was it perhaps A.M. Johnson himself, still sojourning near his residence reduced to cinders? This spirit is not giving up its secrets.

As at the graveyard, the old soldier does not dwell in the aged habitation alone. Two other haunts make their home there. A lighthearted lass likes to frolic there. The unusual thing about this wraith is that she appears to age. While she always appears in a purple Victorian dress, her long raven tresses shining, sometimes she resembles a young child, while other times she gives the impression of a twelve- or thirteen-year-old. I ran across an online discussion from years back involving this particular ghost and her appearance of aging. The speculation was that either the spirit's changed appearance was an effort to have the young lady living in the house continue to identify or play with her or that the entity was, in fact, something more sinister than a ghost. None of those who have encountered her reported any malignant behavior, however, including the adult woman who stayed there as a child. PROSE has several EVPs of this child on its website.

The final ghost of the domain is the singing woman. The lady in question dresses in a pale green frock and has auburn spiral curls. The parents of the home initially thought that she was a typical imaginary friend concocted by their oldest daughter when she was seven. They were still doubtful years later when her younger brother made the same report of a lovely, melodic female presence. They were finally convinced when, after the birth of their third child, they heard her themselves.

One more note about the historic home haunting: though he had no foreknowledge of the occult tenants of this house, the sensitive who encountered the old soldier ghost also related to witnesses a description of both the child and the chanteuse.

Connected to St. Elmo by the short stretch of Cummings Highway, Lookout Valley has some of the oldest homes in Chattanooga, and as one might expect, these dwellings also shelter shadows long dead. Two different log cabins in the area have both claimed to be among the oldest houses in Chattanooga. The lesser-known of the structures has proven more difficult to track down. One, Elmwood, is described in a 1936 *Chattanooga Free Press* article as a log cabin with a huge fireplace at one end, located on the Birmingham Road in Lookout Valley, sitting on a slight rise, with "a gorgeous view of neighboring mountains" and a creek running through the property. There is no log cabin in the Lookout Valley section of Birmingham Highway these days, but if you continue a short distance down that road into Georgia, you'll see a lovely log cabin matching this description sitting on a panoramic stretch of land on the right, near Pope Creek. When I inquired at the post office as to whether this homestead had ever been known as

Elmwood, they knew nothing about that but volunteered the information that the cabin *had* been previously moved.

The newspaper article went on to report the lore of the ghost of Elmwood. It seems that a past resident of the home would have been an appropriate subject for the present-day television show *Hoarders*. Some people hoard food and some people hoard cats. The resident spirit of Elmwood hoarded money, lots and lots of money for those days—$30,000 to be exact, buried, according to those who still tell the tale, under the house. You can't take it with you, but according to the legend, he keeps trying. He appears, they say, every night at midnight in the front doorway of the home, and simultaneously, a pool of blood spills across the floor. Presumably, the crimson puddle is a consequence of his missing head. It is speculated that his death occurred on a wild and stormy night, as he always appears in his raincoat. Perhaps he wants protection from the elements as he searches for his missing money, or maybe his intention is merely to guard his treasure from any living being who might attempt to seize it.

The only log cabin on Birmingham Highway, this dwelling meets almost all of the descriptive elements attributed to Elmwood, being located on a slight rise with a gorgeous view of the mountains, with Pope Creek running nearby. Though it is a short way past Lookout Valley, it is reported to have been moved.

Brown's Ferry Tavern.

While Mrs. Humphreys, the home's resident when the story was written, had not had the pleasure of encountering the ghost, a former resident had seen him "many a time, a-standin' right there in the door." A neighbor offered to dowse for the missing money for a five-dollar fee, but Mrs. Humphreys refused. It seems that she had no desire to raise the ire of the guardian of her home's treasure.

The other Lookout Valley log cabin with a ghostly resident is more well known. Brown's Ferry Tavern is on the Trail of Tears National Historic Trail. The tavern and nearby Brown's Ferry were formerly owned by John Brown, part Cherokee and relative of John Ross. Chattanooga was the departure point for the first two Trail of Tears detachments. Many of the Cherokees forcibly removed from Chattanooga were placed at the tavern for a short time, immediately before this deadly march began. The tavern is thought to be haunted for another reason, however.

It is said by many that John Brown—a popular and genial host who housed many traders both on their way to sell goods and as they returned home laden with gold—would select the wealthiest of his patrons to stay in a particular

2A 14

BROWN'S FERRY

About 3.3 miles north, near the route of the Great War and Trading Path, John Brown, a Cherokee half-breed, established a ferry and tavern in 1800. It was much used by drovers going to and from markets. Legends say that some were robbed and murdered here.

TENNESSEE HISTORICAL COMMISSION

While not directly pointing the finger at John Brown, this historical marker does acknowledge the legends surrounding the robberies and murders at the tavern.

upper bedroom farthest from the other guests, where he would murder them and take their goods. He then loaded their bodies and wagons on his ferry, dumped them in the middle of the river and gave out the story that they had departed in the middle of the night without paying. The murders were not discovered until long after Brown's death, when, according to the legend, bones and covered wagon parts were discovered along the route of the ferry. A nearby historical marker, while not directly stating that it was Brown who committed these acts, does reference the murder/robberies.

According to the tales, bloodstains left on the stairs and in the killing room continue to reappear, despite scrubbing and even removal. Residents of the valley have also reported lights and the sounds of thuds and chains dragged across the floor in the house during times it lay vacant; one person even claimed to see a tomahawk shining in the window of the otherwise darkened house.

I live not far from the tavern, in a relatively new neighborhood. One morning long ago, one of my daughters came running up the stairs, saying that she had heard a ghost in the basement twice repeat, "Hello,

milady." I have to admit that I teased her a little before reassuring her that there was no possible way there could be any ghosts in our house—we had built the house, no one else had ever lived there and certainly no one had ever died there. A couple of times over the years I would stop and chuckle, remembering that incident. Perhaps I should not have been so quick to scoff—years later, when doing research in preparation for opening Chattanooga Ghost Tours, I discovered that our neighborhood had been the site of a bloody Civil War battle.

If you, like I, have been secure in the belief that your dwelling is occupied only by the visible beings you know, just because the building there *now* has had no deaths, think again—we never know what spirits still cling by an ethereal thread to a past long since crumbled into the dust and limestone beneath our feet.

ABOUT THE AUTHORS

JESSICA PENOT is a behavioral health therapist with an MS degree in clinical psychology and is an author of *Haunted North Alabama*, also published by The History Press. As an award-winning fiction writer, she has published two novels, *Death's Dream Kingdom* and *Circe*. She is the author of a popular blog about ghosts and hauntings, www.ghoststoriesandhauntedplaces.blogspot. com, and is a member of the American Ghost Society and the Penn Writer's Association. You can learn more about her at www.jessicapenot.net.

AMY PETULLA is an attorney and mediator who always loved taking ghost tours with her children, though she was surprised that a tourist town like Chattanooga did not have one of its own. So when she stopped practicing law and had some time on her hands, she decided to start one herself. Chattanooga Ghost Tours, Inc., was named one of the top ten ghost tours in the country by TripAdvisor about the time she started work on this book. The tour has proven so popular that it has recently added an investigation incorporating the latest in ghost-hunting technology. You can read more about the tour at www.chattanoogaghosttours.com. Besides coauthoring *Haunted Chattanooga*, she has also written numerous articles for newspapers and magazines, such as the *Pulse*, *Chattanooga Parent* and *Breaking Ground* magazine.